The Future of Our Planet II

*A Collection of Original Poetry
and Listing of
Environmental Agencies In Rhode Island*

Volume 2, No.1, ©2020
Published by Notable Works Publication and Distribution Co., Inc.
Editor in Chief: Noreen Inglesi, Artist in Residence
Cover Art/Illustrations: Mary Ann Rossoni
Design: Second Story Graphics

TABLE OF CONTENTS

MISSION

The mission of Notable Works Publication and Distribution Co., Inc. is to raise awareness for environmental and social concerns through the Arts. Notable Works sees the arts as a valuable means of enlightening, informing, fostering communication and inspiring community involvement.
www.notableworks.org

PUBLICATIONS

Beyond 2000: The Future of Our Planet (2004)
*Original music and poetry by Artist in Residence
Noreen Inglesi highlighting the beauty of Rhode Island's natural
treasures and focusing on the efforts of the local chapter of the
Nature Conservancy.*

*Musical Tribute To Rhode Island Visual Artists
and Photographers* (2005)
*Original Music and poetry by Noreen Inglesi focusing on the beauty
of Rhode Island's natural environment as seen through the eyes of
local artists and photographers.*

Working In Harmony for Home and Hearth (2008)
*A compilation CD project, completed in partnership with
South County Habitat For Humanity,
addressing the housing crisis.*

Love Warms the Homeless Heart (2017, 2018 and 2019)
*A book of original poetry addressing the issue of homelessness with a
current listing of shelters and services available in the state of Rhode
Island.*

Voices of the Earth: The Future of Our Planet (2019)
*A book of original poetry addressing the issue of climate change,
while highlighting the efforts of Rhode Island agencies, which are
making a positive difference dealing
with this crisis.*

*For further information please visit
www.notableworks.org*

ACKNOWLEDGEMENTS

The dedicated frontline workers, health care professionals
and first responders during this Covid crisis

The contributing poets and environmental agencies

Lauren Parmelee, Senior Director of Education,
Audubon Society of Rhode Island

Mary Ann Rossoni
Second Story Graphics

Notable Works' Sponsors and Supporters

Notable Works' Poetry Panel:
Tina Bernard
David Dragone of Crosswinds Poetry
Bina Gehres
Mary Inglesi
Noreen Inglesi
Barbara Pavone
Alison Shea

Members of the Notable Works' Board of Directors

Members of the Notable Works' Ensemble

Notable Works' Volunteers

INTRODUCTION

In this time of Covid-19, there is an inevitable weaving together in our psyche, and hence our poetry, of the fears, frustrations and sense of urgency involved in the pandemic and the crisis of our changing climate. In both cases, humans have a collective responsibility to change, to adapt, to help, and to build a more resilient society. ***In Voices of the Earth: The Future of Our Planet II***, the poets urge us to wake up, to pay attention and to hear what the earth is telling us.

Nature, with all the challenges it faces from human society, still provides us with a multitude of examples of adaptation and resiliency. Our poets remind us that forests regenerate after fires, flowers regrow through dry earth, and rivers still flow down to the sea. They call us to work together as a community to take action on the climate crisis and remind us that we can shift the momentum and make positive changes.

And within all the chaos and crises, there is still the natural world that comforts us, surprises us, and awakens us to the complexity, beauty and power of life. The sun rises, birds sing, fish swim and trees reach for the sky. Through the poetry of nature, there is hope.

Lauren Parmelee
Senior Director of Education
Audubon Society of Rhode Island

POEMS

On Changing the World

We will have to surrender
at some point
or else
sacrifice the quality
of our lives
to unnecessary martyrdom
or stupidity.

We may never hear
the sound of Canada geese
flying in formation
in early fall.

We may never
walk along the rocks
and look to all horizons
in the solitude
space
mobility
and freedom
that some have always known,
taken for granted
and now insist
are basic human rights
for which we fight.

We may never know
a pretty meal
a private room
feather pillows
or the luxury of autonomy.

We have to surrender
because this is not a
struggle
for one person.
One person cannot make the moon
into the stars.

Instead, focus on the
increments
single degrees
smile, words, small
changes.

Watch the drops
as they fall one by one
but nevertheless fall
into the bucket.

✺ *Aubrey Atwater*

THE FOREST STANDS TALL AND STEADY

The forest stands tall and steady
Light pouring through the canopy
Through the leaves and branches
The forest is illuminated in warmth
Plants sprout, saplings prosper
Redwood red as the sun sets
Vibrant life in the ecosystem
Fostering diversity and biological prowess
All is well in the scene
All is well among the trees

The forest glows a little dimmer
Tall broad sturdy trees block out the sun
The underbrush is thick and overgrown
Spirals of vine come down
Encroaching ivy scale the sides of the towers
Snapped of moisture, the scene is dry
Dark is the forest floor
When the fog rolls in, the forest is tense
We are lost trying to be found
It is suffocating

The forest crackles into a blaze
Fiery flames lick the trees under stress
It is alive and tearing into the world
Heat unbearable as it closes in
The animals have long since fled
What is caught is burned away
Pillowing smoke creates bleak haze
Destruction it consumes there is no room
No room to hide strip it all away
Our world is burning today

The forest stands and mourns in silence
Smells of charred wood
Smoke wisps into the air
It is still hot
Dead branches mangled over fallen trees
Is it still a forest?
Quiet
All the tension is gone
Everything is still
Everything is at rest

The forest waits patiently
Left alone to itself for the first time
What will it do next
What wonders are to come
Sprouts stem from the soil
Insects big and small resume their activity
A squirrel curiously digs around in the dirt
Water begins to trickle into a stream
Yes, life is resilient it finds a way
It always finds a way

The forest stands tall and steady

☼ *Jed Lee*

January Thaw
Musings from
Conimicut Point

I turn my face to Sun,
Breathe, close my eyes,
Smell salt air, hear
waves crash upon the shore,
Breathe again.

Warmth on my face
Soaks in vitamin D--
a January thaw?
Winter has yet to arrive
Fifty-three degrees,
feels like Spring.

I hear dogs bark at the park,
Starlings and chickadees.
Brandt geese giggle
As they float by
In the bay.

How many years
Until this bench where I sit
is among rocks under water?
With many more winters like these,
perhaps the whole parking lot
At Conimicut will lie beneath
West Bay.

Yes, I like the warmth
of Sun on my face,
But at what cost?

※ *Patricia McAlpine*

Don't Stop Me When I Say I've Had Enough

I can see the tidal wave
Coming in off the coast,
I'm prepared for impact.
I have no fear of the wave,
But terrified of who I'll be after it hits.

❈ *M. Neil*

COVID FABLE

Once,
In the life
Of a certain
Planet,
There came a time
When its inhabitants,
In order to preserve
Themselves,
Were compelled to stay
In their homes,
To cease
Their accustomed manner
Of existence,
And to isolate
Themselves, even
From those
They most loved.
And not all
Were spared,
And the dead
Waited their turn
To be buried,
And the rites
Could not be
Observed, and
They were mourned
From afar.
A long time
Passed
In this way,
And life
For the beings
Began to change -
They no longer cared
For the frivolous
Knick-knacks
They once thought
They needed;

They valued now -
As once they
Had, long ago -
Simple pleasures,
Essential
Things:
Nourishing food,
Music and stories,
And the light and
Life around them.
Perhaps some
Were healed
Of old wounds;
Others, perhaps,
Shuddered,
Refused to change,
And, finally,
Succumbed to an
Incurable bitterness.
Eventually,
In good time,
The trial was over;
It was safe to
Breathe the air
Again, to embrace
One's neighbors -
Freedom had returned
To the world.
The mood was festive
In this time,

Hope was restored,
And there was
Much energy
For the work of
Rebuilding
Their society.
But, when those
Who had clung,
Selfishly, to the old ways,
Said:
Now we may open
The shops again
And all may partake
Of their offerings!
They were surprised
To find
That no one came
To those places.
The People
(As they called themselves)
Were, just then,
Much too busy
Dancing
Together.

✺ *David Luken*

HEALERS

They say a famine circles—
a puma set on heavy claw
with silent paws the size of dinner plates.
Hunger glowing in each eye,
ribs articulate the barrel of its chest.
Meanwhile, the masses buy up
all the meat to freeze
and all the paper goods to hoard
as though each chicken breast
and package of TP is but a flag
to capture first.

But I have seen the local farmer
take the blunt butt of the lettuce,
the potato, the onion, the herb,
place them tenderly in jars of clear water,
tuck them gently in the downy soil to grow
again and gift unto the stranger,
because they can—they know
the meaning of regeneration.
Those for whom the shelves are empty
must not need. Those who have forgotten
how to sow can be taught. I have seen
the ascendance of teachers.

People hide within their homes
as a sickness spreads—turns pink
lips and digits blue as it settles
in the flayed wingspan of our lungs.
They say the pecking order matters,
though it is only a matter of time.
Assuredly, many will fall prey
to the talons of the ruthless—flown away
on high with a breathless flock.
Some will shut their eyes.
All who can will keep their distance.

But I have seen the medics
tuck their children into bed,
kiss family goodbye, and wave
from deep within the cast of the pandemic.
Donning gloves, gowns, masks
(the things we wish were spared
for happy carnivals), they stand guard
all hours by the bedside of the gasping.
Though they are tired,
though their feet would fail,
though their faces bruise
under the chaffing of their vestment,
they will offer healing.
They will lead the lost to light.

✺ *Emily Cooper*

April 19, 2020:
Dear Humans; Dear Covid

Oh, humans, we have, unawares, hurt the earth,
Ourselves a pandemic.
And the earth has rallied its own pandemic
To hurt us.

But, my dear Covid, do you know what you do?
Do you have regrets? Do you recoil at the death you cause?
Do you cry at night with images of bodies in bags?

Have you thought of ways to live in peace?
Do you embrace your fellow pathogens with love?
Do you sing to lift the spirits of your surviving brothers and sisters?
Do you care?

And, my dear humans, do you know what you do?
Do you know your new soldiers?
Do you suffer in sympathy with those,
Who, with reddened face from medical mask, smile
And tell us we will get through this together?

For they are the soldiers now, those who protect
Us, who risk lives:
We tell them we love them and they tell us
They love us. My dear Covid, do you know

What I am saying? And my dear humans,
Who I too love, do we see now that our
Soldiers fight for the species, not the flag?
Do you see the global rise of humanity?
Do you see how we can be more than a pandemic
Ourselves?

Pandemic Covid has not stormed the beaches
Nor airlifted into our cities,
Nor divided us, not an autocrat,
But has stealthily made each of us
A danger to other humans, has
Tried to strap viral bodies to us
So we explode in sneezes
And bring down supermarkets.

Covid turns us into our own enemies
Turning us against each other,
Distancing us, separating us, we who long to
Hug our children, who long to gather and smile!
To smile! And shake hands!

Humans face you, Covid, and glare defiantly
And bang pots at 7 and hang signs on
The streets and make our hands
Into hearts so our new soldiers know
Our love will protect them.

Dear humans, we are not a pandemic but
We have hurt our earth as if we were.
Like a virus evolving to be more civil
So must we.

☀ *Trent Batson*

DEATH BE NOT BOASTFUL

This work was inspired by Rhode Island Arist
Gail Armstrong's Painting "On the Beach"

Death be not boastful of your bountiful triumph.
Instead be mindful of the consequences and the hardship
Your victory has brought about.
Like a spotted leopard you camouflage yourself
Crouched behind the fresh green branches of the scented pines
Always ready to pounce on your unexpecting spoil.

Feel the painful pangs of life's unwilling consumption
As if just pricked by the sharp thorns of summer's rose
Suddenly plucked from its moist, thriving stem.

How precious is life
Yet so fragile,
So momentary,
So easily taken for granted.

We zoom through each day
Without so much as a pause for silent reflection
On the bright sun's triumph over a dark night
Fighting off all thoughts
Of Death's anxiously awaited victory
When Life's roaring flame
Is quelled by Death's powerful breath
And fades silently into a twilight sky.

☀ *Noreen Inglesi*

SHELTERING IN PLACE

The whole world shelters in place
 and the earth takes a long, slow breath
 and readies herself for spring
 by giving us five inches of snow just to see if we're paying attention

She then begins to slowly change her clothes
 from winter's browns and grays
 to spring green dotted with yellow...forsythia...daffodils...
 and little purple flowers like tiny stars in an upside-down sky

There are rumors of dolphins in the waters of Venice
 and an absence of smog in Los Angeles
 and here, our lakes and streams run clear
 and the woods are full of bird song as I step outside

Lucky to be among the maple, oak, ash, birch and pine
 to hear the river sing, so full in her banks
 I'm grateful but can't shake the feeling
 that if this world doesn't work for all it isn't working for anyone

What can this old woman do to help?
 Stay home? Is that all?!
 It seems too easy - and feels like not enough
 all this time in isolation sheltering in place

The earth takes a long, slow, deep breath
 I do the same, in through the nose...
 nice and slow, let it go...slowly again...
 and then reach for the phone...call another friend...

☀ Jan Luby

THE MAGIC GIFT OF YOU

If you're feeling stressed and lonely
And you don't know where to turn.
If your head is pounding madly
And your chest aches with heartburn.
If your stomach's doing flip-flops,
And you're feeling so abused,
If the million things you're doing,
Make you sad and so confused-

Try to stop and take a deep breath.
Watch a bird light in a tree.
Try to listen to the melody,
He sings so beautifully.
Feel the breeze as it is blowing.
Let it kiss and lift your hair,
With the power it has carried,
From a distant land so fair.
Raise your face up to the sunlight;
Warming rays that shine so bright.
Try to think about life's magic,
That it soon will help ignite.
Just remember what's important,
In the larger scheme of life,
When you're stressed and feeling harried,
As frustration adds to strife.
For happiness stems from within,
Accepting as you go,
The challenges you face in life,
With all you come to know.
As you learn to compromise and grow,
Through all you come to do,
When your heart can sing believing in,
The magic gift of you!

❃ *Janet Barron*

PRACTICING SAFE FRIENDSHIP

The invisible Covid-19 Army marches inland, invading our systems, becoming an occupying force in our lives.

Despite the horrors, irony prevails. We learn the best way to fight the assassins is with our absence. We proclaim lawful assemblies unlawful (or at least unwise). And even in these days of loss and fear, there are those who flaunt a specious independence above regard for others — putting lives at risk — proving once again that our culture of denial is the deadliest disease of all.

This "occupation" has inspired a new mode of relating: The Practice of Safe Friendship. Social distancing creates opportunities for intimacy, often with family but also with deeper layers of self. Instead of rearranging the deck chairs of one's life, we have the chance to go down to the engine room where the heart beats, where the real work is done.

And when one embarks on that next layer of heart-work, the dynamic between self and others can change: boundaries re-examined, bandwidth widened, spreading, from person to person, to repurpose a nation.

And the graph of American compassion is rising. Tens of thousands of people from all walks of life have volunteered their service – some, heroically, as first responders. The list grows daily.

Here, from my perch in Providence, I want to give a shoutout – to all who practice courage and generosity on the frontline, and all who fight the disease by honoring difficult guidelines.

And when we finally begin our post-pandemic lives, I pray we will continue to deepen our friendships with each other, and our endangered Earth, where we are Sheltered in Place for as long as she will have us.

☀ *Thomas Lane*

OUR UTOPIA

I am a utopian dreamer

I feel the glaze of the sun on my body
As I sit in our sacred temple of divine greenery

No fear is found nor is the depletion of our cherished temple

When the clouds become gray and the soil soft
I retreat to our utopia
To our greatest star
Our temple of heavenly beauty

And gaze in awe

☀ *Viola Everett*

An Indeterminate New Day

When brilliant sun gives way
to dark and misty night
when sweet mirth
acquiesces to bitter dolefulness
tuck inside like tortoise
with camouflaged resistance
recharging and gathering inner strength
'til circle dancing midst vibrant sky
within boundless walls
until mighty enough to face
whatever lurks outside
whether tender breeze
or ferocious storm
basking in the armored glow
of accumulated
and reinvigorated passions
until amassing the energy
to revitalize
and to launch
into an enduring
and indeterminate new day

Noreen Inglesi

NATURE POEM

Nature
Full of senses
Nature smells like fresh air, dirt, rain, blooming plants
As the seasons change the earth dies and comes back to life

In winter, nature is dark, sad, and everything is dead.
The snow starts to come and everything turns quiet and pure.
All we feel is cold shivering our bodies.
Winter makes us curl up in a ball and hideaway.

Then one day the world comes back to life.
It starts to get warm; outside spring arrives
The plants bloom and flowers shine in the light
 like sunshine in stained glass
The birds start chirping to the tune of my favorite song
Nature is full of colorful flowers fragrant smells
A lot of rain helps plants to grow

Then summer comes and the trees and grass turn green.
More of the plants and flowers come out.
The days are long and hot leaves provide shade

Fall arrives
With shorter days
Color palette changes from blues and pinks to gold and orange
The fruits of the summer are ready to be picked
The nights become crisp
The colors become vivid in the fading daylight

Hopefully, Future Generations get to experience the Four Seasons
Enjoy the senses of nature.
Smell the flowers, feel the rain, hear the birds sing,
 see the beautiful colors,
And taste what the earth has to provide.

✺ *Tessa Caporelli*

SPRING SIGNS

Heavy snow lies thick and lazy on the silent ground;
Sand stained, discolored now, it pushes 'gainst the freeze beneath
And craters at the dormant trunks of trees and stems of shrubs.
Its burden is to bear the promise of a spring to be,
Unbothered by the wizened winter past.
The pack succumbs, if slowly, to insistent sun,
Recedes beneath itself
 in a slow
 dance of
 disappearance . . .

Jim Manchester

THE LITTLE POND

Can you see the little pond
Untouched by the world?
Its flowers dance in the wind
As birds sing high above

Can you see the little pond
Way behind the house?
The flowers still dance in the wind
But the trees have been cut down

Can you see the little pond
In the middle of the park?
A bench is where the flowers were
And the waters getting dark

Can you see the little pond
Forgotten by the world?
Her water dark and murky
As the world around her swirled

Can you see the little pond
Noticed by the children?
They planted flowers at its shore
And used determination

Can you see the little pond
Thriving among her friends?
While the flowers dance once again
And the birds fly over head

Can you see the little pond
Where people go to dream?
Her water nice and clear
As the happiness around her gleams

✹ *Sophia Spano*

NATURE'S SOLACE

Walk in a wetland
Winter into spring
Water fills the pond
laden with duckweed so green
from surface to depths below.

Wind blows, trees speak
rub against each other, broken
lean on one another.

Five deer pass by
in the weathered meadow.
They sense my presence
We commune together
linked in nature's solace.

※ *Patricia McAlpine*

MY BIKE

Riding on my bike
Autonomy and union
Become resolved

※ *Chris Menton*

AWAKENING II

With ease gentle bliss
Willow's arms bear the mist
Wakened peacefully
With day's first hello
Wake up bleak valley, bask in glory
Wake up dark meadow
Breath in brand new day
Making its way
Bursting through with pastel sky.
Flowers sway
Gently in the meadow
Raise their heads
To sip sunshine perched on limb
A robin sings with glee
Glad to be flying free
Cloaked in light and gentle breeze
Vibrant day's ecstasy
Creatures feast
On the lustrous fruits of the meadow
Lively springs mirroring
Phosphorescent glow
'Til at last waving goodbye
Light of day fades away
Twilight sky sneaks in from the west
Day's sun finally rests
Willow's arms droop in silence
Songbird longs for
Another joyful jubilant tune
Deer stands stoically
Hoping to soon see the moon
Distant stars still too far to see
Make their way so leisurely
Crimson sky though try with all its might
Darkness wins the fight
Yet in air still lingering
Perfumed scents and
Everlasting brilliance

✸ *Noreen Inglesi*

UNTITLED

I sat at White Mill Pond this afternoon
The sun was low in the late October sky
but it was still warm there on the stone wall
with the water rushing over the dam
and beyond
I closed my eyes
and watched my thoughts go by
as the stream splashed off into the woods

and I noticed my breathing
the rustle of leaves in the wind
the sound of passing cars and a dog barking in the distance
and my heart ached with loneliness and longing
and at the same time was so full of everything alive

air filled my lungs again
sun warm on my back
and still the dog barks wanting to be fed,
wanting to be let in
and I know how he feels because I am the dog
and the stream
and the bridge
and the skinny bare tree growing in the middle of the cold rushing water
and I am the woman preparing supper for a noisy brood too busy to let
the dog in
and I am the wind
and the last yellow leaf falling in a whirl to the ground
I am the ground covered with leaves
and I am a pen dragged across a page
and I'm a piece of paper that once was part of a tree somewhere
and I am the ink
I am this breath
I am this noisy brain
This hunger that calls me from the page...

❀ *Jan Luby*

THE MONARCH EFFECT

The monarch effect
"while birds and warmer weather
are forever moving north,
the cries of those who vanish
might take years to get here."
–Carolyn Forche
for Homero Gómez González

In the photo, he is thick-necked and sturdy
as a five-hundred-year-old Spanish oak bureau
in Michoacán, as heavy and unmovable.

Monarch butterflies rest all over his shirt
and khakis. If you close your eyes,
you can see them slowly flap wings,
barely moving air. You can see the darkness
of the bottom of the well where they found him.

In the photo, in spite of butterflies, he has no smile.
Fully frontal, he confronts the camera
as the industrial gaze: a choice to communicate
with an unknown afar:
and here I am en el norte,
where in the lengthening days of August
the monarchs will rest.
I am here where the butterflies chew
thick leaves of milkweed
and blend their orange with butterfly weed blooms.

Once, when a new farmer, I killed a caterpillar
thinking it was a tomato hornworm.
Green and yellow and black,
I should have known better.
I tried to feed it to the chickens,
said to love hornworms,
but they just looked at me strangely,
that way they do.

I am at the bottom of the well
where they found him dead.

One day the only orange to see may be the flowers
I planted to feed the butterflies
who no longer return,
a banquet set to empty chairs.
The one I killed, might have been
the mother of thousands.

This is how I pretend to power:
guilt is easier than helplessness.

※ *Karina Lutz*

https://nypost.com/2020/01/30/
homero-gomez-gonzalez-prominent-
butterfly-activist-in-mexico-found-
dead-in-a-well/

CRIES FOR HELP

Mother Nature screams terribly
If we don't hear her loud screams for help,
Then who will?
Terrible trash turning the streets into landfills
Oceans overfilling with plastic
The temperature is rising but no one seems to care
How can you make someone aware?

Aware of all the trouble they are causing for our beautiful Earth
Aware of the rising climate
Aware of the melting sea ice and glaciers
A
 W
 A
 R
 E
If only you could see the terrible impact you have
Do you not feel bad?
Or are you glad?

Are you glad that the next generations have to deal with the problems you
helped to cause?
Are you glad that you are destroying the Earth with every piece of trash you
throw on the street?
Are you glad that Mother Nature is screaming?
R
 E
 F
 U
 S
 E
Why do you refuse to listen?
Oh how I wish to see Mother Nature's smile glisten

Bees will buzz filled with delight
As we live sustainably
Moving on with our lives
Trying to spring Mother Nature back into shape
Getting rid of all the pollutants we have
With that all the heat will escape

As Mother Nature cries for help
We have no choice but to stop and think
Think about what she has felt
As we have only made the climate worse
Helping all of the ice caps to melt

It is time to change our point of view
Help the planet is all we can do
Now is time for our breakthrough
If I can do it you can do it too

❊ *Jaeda Medina*

WILD

They've been in the backyard this whole time
in the far field, near the campfire pit,
trembling and skittery.
When we were all out there whooping it up
there were lots of them,
though you'd hardly know.
Except occasionally when a reveler
would glance across sparks
spiraling into a dark sky
and see glittering eyes,
barely perceptible
through branches.
Scruffy,
ignored,
they were
waiting
for the crowd to die down
for the wind to carry a bit of heat
for a scrap of junk food,
a taste of spilled beer.
Things would get so loud
you couldn't even hear
the howling.

Poems are everywhere
now that everyone has gone home.
It was a desert,
ruthless winter
for resilient creatures
who now creep forward,
ears and tails flat against fur,
crawling closer, closer to the fire.

Although they are still quick to run away
their worried faces illuminate
in the inviting light
and thin bodies quiver in plain view.

This one came right to me
boldly,
with matted fur on her legs
and a wild look in her eyes.

Aubrey Atwater

RED HEAD ON ALERT

Alert . . .
she scans with upright head the thorny thicket of the shore;
(who knows what dangers lurk beyond the boughs?)
 ten thousand, thousand years of instinct
 taught her how, inform her now
 to tame a tortured terror deep within.
Soft, red russet feathers tense . . .
 belie a nature quick to respond against a gathering storm
 as
 yellow eyes cast fast
 to escape the hunter's blast!

Jim Manchester

Mother

She is changed,
the way she looks,
the way she feels,
her winds are stronger,
her waves pound harder,
her fire is intense and swift.
She is fighting back
in her struggle to survive.
She is slowly dying.
And as she dies, I die,
for I am connected to her,
a part of her, from her.
We all are.

Yet we are her murderers,
we are killing her with misuse.
Mountaintop removal, Oil and gas extraction,
Sedimentation, Erosion, Deforestation,
Species impact and extinction, Climate change.

In our greed for more,
we devour all that she is
ignoring the consequences.
Instead, we believe that she is ours
to do with what we will.
But she is not ours to control,
we do not own her;
we are merely visitors.

We are killing what gives us life
and she has reached the point of no return.
We cannot live without her
and we will not survive without her,
but she can live without us.
Once she has rid herself of us, she will thrive.

The tides are shifting,
the seas are rising, and
we will be washed away
in her purge and regeneration.

✺ *Mary Gutierrez*

THE SELF-ENTITLED APEX PREDATOR'S APOLOGY

Am I blind to your pain or choosing to be ignorant?
If you could communicate,
Would you scream for help or anger?
If you could hold to the ground that you call body,
Would you fight or plead?
If you could save something,
Would you save the wild or would you save me?

Thank you for the memories,
For the childhood of overgrown vines, sunset and sunrise.
I'm sorry for the damage,
For the greenhouse gases, explosions and crashes,
bloodshed over valued paper and taxes.
I'm sorry for the oblivious habits of humans
I'd say we're trying, I'd say were learning
But are we?

Humans have powered through to overcome and evolve
With you as the price
Sustainable lifestyles,
some fawn over some despise are truly what we need to do
Let's build new renewables they say
Backwards to the burning to burn a wind turbine to stop burning
Absurd isn't it
You are the resilient sustainable goddess we strive for,
but shall never achieve
The classic human dilemma: cherish or char?
Shall we leave you to die or us?
Who shall be the sacrifice?

Survival of the fittest doesn't work
when we depend on one another to breathe
And in a world where even the air we need
and ground we have conquered is momentary
An apology cannot make correction of the destruction
from a self-entitled apex predator
I shall never know the damage I am capable of
Until I open my eyes
But then I know I'd rather wish to be blind
than see the destruction we put onto thee

✸ *Sonia Gracer*

A Reason

Everything in nature needs a reason

The lakes and rivers affected by climate change
still provide a home and nourishment
for the fragile life below the surface

In forests, trees left bleeding by axe or fire
drop seeds to the earth before the final limbs fall
insuring us a future of clean air and protection

Nature, trying always to maintain itself
carrying on the legacy of the universe
and the deep-rooted knowledge of what should be

Those among us without resources, without security
with feet planted in shifting sand
struggling to make sense of the senseless
rising in the darkness of early morning
riding in silence to factories and farms

Every day in a country divided by rich and poor
where the language may be strange, the rents too high
where the sunlight can't penetrate tenement walls
folks manage to survive when survival is all they have

We all find a reason to continue.

✺ *Elizabeth Bogutt*

More

On our finest stationery,
We spelled out a December wish:
More, please.
More toys scattered in the grass,

More devices attached to our fingers and ears,
More logos stitched across our bodies.
More bulldozers pushing cranes out of the sky,
More cars blocking up the veins of our cities.
Getting us to more places,
So we could get more.

And we got more.
We got more factories, more mines,
More oil rigs hooked up to the heart of our planet.
More greenhouse gases in the atmosphere.
More ice melting,
Waves rising,
Storms raging,
Heat scorching.

In the stunning realization of what we have done,
We take back that wishlist,
And we turn that flimsy list of hopes
Onto the other side.
A new blank slate.
Ready to fill it with wishes for more.

But this time,
We ask more of ourselves.
We ask ourselves how we can give more,
And our neighbors how we can work with them more.
We ask how the richest countries can do more,
And how the world can agree more.

On the back of these wish lists,
We write memos and op-eds,
Scribble down songs,
Sketch out posters,
And write new kinds of wish lists.
More protections to save the creatures in our streams,
More panels to accept the warmth of the sun,
More outstretched hands to stand with our most vulnerable
communities.

When each day asks more of us,
Asking what will we do to be resilient,
We share our answer
In front of state houses,
On phone calls with senators,
In town meetings:
More.

☀ *Sarah Lettes*

DIPTYCH

I. Landscape of consumption

I'm so tired of the faux facades
of the "landscapes of consumption,"
like this mall built to look like
the village it supplanted
(lights in second story windows
with no rooms behind them
illuminate only drapery and the parking lot);

I'm so tired of being American,
of this 'we' that keeps implicating me
in all kinds of atrocities,
in my insufficient resistance,
in the insignificance of my concern;

so tired of the facades splayed
with brand names in elegant fonts
of automated recognizance,
of the logos and logoi and designs and reasons of consumption,
the artistry of my people spent
on storefronts and billboards, ads
and special effects. I want to be unaffected:

to resist, resist, resist the purchase.

But the best of my people's psychology, too,
is employed to transgress my resistance,
to subvert our sufficiency.

We have had enough.

II. Landscape of production

As antidote to the trip to the mall
to watch the movie to know what
we have done with our history this time,
I bike the landscape of production,
weave the potholes of the parts of town
no one goes to except to work, if necessary,
and it's always necessary
for some.

Then, as antidote to the engineered and treeless
'neighborhoods' (you might call them
if the homes were close enough to see
each other around the sewer treatment plant
and oil tanks and adult establishments.
Sure, I am adult too, and that is one of the few spaces
off this street I am free to enter,
but I can only imagine
the discomfort of being ogled with questions
by those poor shame-debilitated men
having so much trouble getting to maturity),
 I leave my bike at the bridge,
and walk upstream past the old mill to the unfilled
wetlands, still unbuildable, so far.

I find trees and breezes and the small wildlife
we once took for granted, I think, though I don't know
who 'we' is here, either, certainly not us-as-children,
when a pigeon's iridescent neck would mesmerize,
a squirrel would be welcome in the attic,
and a robin a sign of something.
I'm so tired of being American,
of this 'we' that keeps implicating me
in all kinds of atrocities,
in my insufficient resistance,
in the insignificance of my concern.

✺ *Karina Lutz*

CHESTNUT, ELM, MAPLE

I know I am dreaming but I cannot wake up.
I shake myself, but it is not the earth body, it is the dream body
that shudders.
I know I am dreaming when I drive down Maple Street,
loving the gorgeous maples while I kill them with my exhaust,
but I cannot stop.

I know I am dreaming when I turn onto Chestnut Street
and there are no chestnut trees.
I know I am dreaming when I turn onto Elmwood Avenue
and the grand elms have long since died.

I remember hearing that they were dying
as a child, but didn't know which tree was which,
which to mourn,
had been taught only maple and oak
by my city-born elders. Had no idea how permanent
the loss of a species would be. But we were awake

as we played along the streets, pretending they were rivers,
deep and wide and flowing as they should.
Once or twice a year, in late August, four inches of rain in a day
would flood the streets, and they would almost become rivers,
shallow and wide and flowing and we would thrill, the rain
warm enough to run in, the earth body and the dream body
of the rain one. The earth body and the dream body
of ourselves and the rain one. We were awake,
with rain down our spines; our earth bodies shuddering,
shaking the rain, both rain and spine shuddering, laughing.

The rain would wash the streets clean,
sweep litter and maple helicopter-seeds alike
down the storm drains
to the real rivers—litter and leaves and seeds
and floating gasoline rainbows
rushing toward the real rivers,
hidden underground.

✸ *Karina Lutz*

Do You Know...?

Sometimes,
I trick myself.
Sometimes,
I catch myself up in my life
in this world, in the West,
in the opaque glass house we've constructed
as a monument to ignorance.
I see the world as it is, and not as it actually is.
I forget,
even if for just a minute
the Truth that I will never forget.
The Truth which
you only know you actually know,
once you can't forget it but for a sweet minute.
And at one full rotation of the second hand
As the start of that second minute is handed to me
like a cold shower in the face.
The second I realize I've stopped understanding fully,
I understand fully,
and I rest my face in my hands
as reality melts away around me,
letting me see reality more clearly.
Every word, about food or music or TV or sports,
Every sentence about some other this or that
Is punctuated, silently most times
with the question: but do you know?
Do you know the world is ending?
And each dive deep into life's ambition
The voice of my friend asking the question
of my 5 and 10 and 20 year plans
Is answered, silently most times
With another: but do you know?
Do you know we have just 10 years?

I live
and the world lives around me
Rivers running polluted, and the course of society running like a river
as if each molecule, each individual running within that river
Does not realize it flows...
into a waterfall.
It ends
in a violent, unforgiving cataract
But silent.
Punctuating the river,
silently.
Like an exclamation point,
turned on its head,
a silent scream.
Like the questions my mind dwells on
While my mouth and ears dwell on the distractions of this world.
And only in the brief second,
while my hand covers my mouth and ears and eyes and nose and heart.
Only when the distractions I make and I perceive finally cease,
The silent punctuated questions of my mind
can scream of their own volition,
flying out of my mouth like an excited flock of birds
who revel in the warm February sun, not knowing it's The End.
Questions that punctuate "normal" sentences more violently than
an exclamation point:
"But do you know the world is ending?"
"But do you know we have 10 years?"
"But do you know?"
"But...?"
And I no longer forget.

✿ *Alex Kithes*

TOO LATE

It wasn't that long ago
That Man restored the land
At Allin's Cove.

A salt marsh,
An upland,
A relocated channel,
Two osprey poles,
Native grasses, shrubs and trees,
Returned a decimated cove to life.

The cove replied with
Mummichugs,
Tiny flounder,
Seaside Sparrows,
Ospreys, egrets,
Ducks, herons, gulls.

Newborn salt marshes sprang up
In defiance of rising tides and
Threatening sands.

Two decades ago
There was little talk
Of climate change;
That acts of Man could launch
The universe's fury
With storms and rising tides.

Acres of tide born sand
Displaced the water.
Erosion reshaped the shoreline.
Tidal water crept in
Drowning the marshes
With nowhere else to go.

Full moon equinox
Swelled the cove
Lapping at the grassy bank -
Standing yet.
Rising waters will claim
Man's intrusions.
Storms will wash
The weakened land.
It wasn't that long ago.

✿ *Sandra Wyatt*

Sunday Afternoon

Sunday strollers on the promenade,
the factories closed,
the river almost-blue, almost river-like.

The river-bank as it should be, elms
not yet sickened, green
thickness of willows.

Mallards strut, iridescent.
Sun-turtles shine in the muck,
an eel glides

luminous, past
boys fishing for pickerel
in the shallows.

Upstream, children build rafts of sticks,
to watch them drift off,
break apart on the lip of Pawtucket falls.

A father and son skipping stones, circles
ripple, one into the other
as evening comes.

Tomorrow, the violence again.
The river goes crazy with color
the mills spew into the Blackstone...

It's said, you can tell what the mills are doing each day
by the color of the river.
Mustard, vermillion, lime-green, magenta on Thursdays...

Branding and burning the river—
heavy, heavy metals, dyes, varnishes, solvents, bleach
and a dark-red poison to kill the cotton seed bug –

a hot effluent slop
raging seaward, forty-eight miles
from Quinsigamond to Seekonk,

with all the waste that perverts this river,
all the measures destined for her soul. *

✾ *Mary Ann Mayer*

* reference to Wallace Steven's poem "Sunday Morning"
(Previously Published Ocean State Poets' Anthology 2016:
The Worked, We Write, Editors, Juliana C. Anderson and Will Anderson.)

Hidden Place

There is a place where she hides
Behind the tall, strong trunks of the trees of the forest
Around her,
Everything is burning to ash.
There is a place where she hides

Once the glaciers were cold and tall,
She never thought
That they would melt away.

There is a place where she hides
Down below the waters
Swimming in the coral with the fish
No longer will she see the beautiful colors anymore

There is a place where she hides
She wants to call it home
But mother has cried so much,
The sea has taken it away

There is a place where she wants to hide
But she can't
For her temperature is rising
And by each day she is getting more sick

There is a place where she wants to hide
But she can't
For the air outside is no longer oxygen
It's carbon dioxide and particulate matter

There is a place where she wants to hide
But there is no safe place
Her home is on fire,
Her tears are plastic bits.

There is a place where she wants to hide
But where can she hide?
There is nowhere left to go

☀ *C. M. Conlon*

ENDANGERED SPECIES

Amazon rainforests burn
Monster storms churn.
Wildfires, ice melts
and temperatures and seas rise.

Mosquitos carrying disease
multiply and stay longer.
Bring out the insecticide
And wait for another silent spring.

Endangered species no longer protected
Humans in danger of destroying our planet,
destroying ourselves with ignorance and denial.

Where do we turn, will we return to God?
Whose God? God of dominion or God
Who made us stewards of the Earth.
When will we learn? We are the Endangered Species.

✺ *Patricia McAlpine*

LOST AND FOUND

Some things we say quietly to ourselves,
Over and over they sound the same.
They would sound so differently out loud.

Words and actions, representing the melting
Of all into one. Time, consequence,
Yet our vehicles for understanding fall short of comprehension.

The only way to know anything is to let go of knowing anything.

It sounds so silly, the truth so filled with everything
One may mistake it for empty.
How could this be?
Concoctions colliding qualities constantly changing against confined boxes.
Boxes to encase the madness of our own creation.
Labels that make life easier at the cost of making life harder
Invented because life was too hard for our ancestors to survive in.

These things exist without us just with different names.

Humans, chasing, the subjective experience of themselves,
Yet that fragmented reality flashes only for a moment in the heart of the
universe.
I don't want to talk about your day or the weather
Unless it's talk to dissolve the particular importance of these things.

Can we talk about how none of it matters and dance instead?
Can we sing songs that somehow make sense of these cyclical mistakes.
Not with answers but by making light of the question,
Making dark of the question,
Being one with the question,
Getting lost in the question,
Becoming, the question!
Who am I to question?
A human lost in answers that don't make sense when
We are climbing an infinite staircase of regression.

Too tired to go on, I'll swing from branches
Not for height but for depth -- not for strength but for grace.,
To careen through the debilitating madness of our culture-so-called
Until I can find my place,
In the motion, of change.

✺ *Nicole DiPaolo*

ENERGY OF CHANGE

In this new world order
is God finally putting His foot down
telling us Enough?

Is Mother Nature raging her wrath
telling us Enough?

Is this Virus a message from the Universe
reminding us we are in this together?
Either learn to play nice with each other
or face the consequences.

We should use this time wisely,
reflect on what is important and necessary.
One day at a time. Breathe.

Hold this moment close
to our hearts. We have a chance
to recreate life - more in balance,
more in harmony, more at peace with one another.

If we pray, listen and learn,
we can be transformed, healed.

This is a time for renewal,
A time for improved possibility.

Patricia McAlpine

THE IDEA

Starts with one idea,
This idea inspires others,
Small ideas help too,

This idea might be,
Plant a tree or recycle,
More ways to help are,

Support the government,
Such as the Act on Climate,
Bills will help change laws,

Any age can help,
You can still share your voices,
Support your beliefs,

Influence others,
Change can happen because it,
starts with one idea.

Fabian Torres

THE INEVITABLE

The magic is terrifying
A picturesque nightmare posing as paradise
Muddy waters mask everything
Drifting to the far shore
Unseen under the guise of fall trees
Mustard leaves fly aimlessly
An unbearable wind breaks
It all starts to disassemble
The first boulder crashes
Waves overpower
Bystanders scramble
But too much has fallen
Paths to escape caved in
Rocks rain as the sky opens
The landscape sits ablaze
Escape is unnecessary
Panic consumes all oxygen
Red berries in the distance
Focus and atone
Beauty always hidden somewhere.

❈ *R. Forand*

NATURE'S PATH

I walked up to Garden Street and I wondered
 What if the earth was adored?
 What if we lived in warmth and equilibrium together?

When spring ended, I noticed this beauty shifted and bended.
Like daisies dying.
I looked up to the sky and said
 "it's spring here!" while fall's first breath already started to come around the bend.
It's called climate change, don't you know? They said.
That everything beautiful must end
But, as the flowers died and the sun was sheathed
I admit the world remained as beautiful as it had ever been.
As if, from all the mad grinding in my brain, a single lily had grown in the snow where it never belonged
This lily represented hope for change.
But it was plucked by our collective hand.
When we refused to respect this beautiful land
And her circadian rhythms

We pumped oil into the seas, CO2 into the sky,
The glaciers started to melt and we stood by and wondered why.
We did not take the blame.
We said, it's only nature, the seasons change.
But there is more carbon dioxide in the air than there has ever been.

The earth survived for millenia without our intervention.
The lily is glad that we breathe, makes oxygen for our noses overcome with greed, yet we cannot
appreciate her growth.
For every complacent step we take, we see one animal dying behind us,
We forget to say thank you as every forest dies faster.

With every single dark memory and every single dead cell
I stand here wondering if the earth has a future.
air pollution and climate change threaten her.
And it's all at our hands, roots around our hands.
Nobody realizes as it gets hotter.
As we get colder and colder.
And nothing gets better.
They ask
 Why is my world on fire?
And they hold the gasoline

We must derive power from the earth beneath our feet.
We must join the sparkling lights that dance upon the sea,
Everything we touch is part of everything we have ever known, and it is
beautiful.

※ *Bryan Rios*

WATER SHED

The green expanse of duck weed
Parts and there he sits,
Proud - or so I imagine -
In all his feathered iridescence,
Shedding water with neither thought nor effort.

The late Spring rains
Fall on Sonoma Mountain and English Hill,
Filling the Laguna and Atascadero Creek.
So Wintergreen becomes Summergold.

But where are the salmon, the steelhead,
The pronghorn and the grizzly?

There is so much for us to grieve now,
So much lost that we will never see again.
And yet so much still to be revealed
That we cannot yet imagine.

Can we shed despair
As we shed our tears
And see with clearer eyes
The shining form just now emerging?

Larry Robinson

THE WOONASQUATUCKET RIVER SONG

VERSE 1
Working for our river
To keep it clean.
Someday we will fish again
And we'll swim in the stream.

Refrain
Nineteen miles does it flow
So much life in this river
Telling stories of long ago
A very special part of history.

Verse 2
Hidden in its splendor
Gently flowing through time.
Winding steadily through our town.
Marking traces left behind.

BRIDGE
We're cleaning that old river
Giving back its glow.
It won't be long before the water
Sparkles as it flows.

Verse 3
Working for our river
Wading in water as it gleams.
So many worked as one
Sharing this great dream.

Refrain
Nineteen miles does it flow
So much life in this river.
Telling stories of long ago.
A very special part of history.
A very special part of history.

❀ *Noreen Inglesi*

NATURE AND US

It is all around us
The trees, the bushes, the water
When the sun emerges and shines all around
 like a giant light illuminating the forest
The best parts of nature begin to show
Great green forests that are untouched by man
The deer and bunnies venturing in the woods
Peaceful little birds flying through air
Nature is very strong and has adapted
But it can only adapt so much
We can help it if we try
To bring back forests
We can co-exist
Hand in hand
Side by side
We can save dwindling animal species
We can bring back their homes
We can make less pollution
We can be more eco-friendly
Together we can save the beautiful green planet
 we call home.

※ *John Boulmetis*

GAPING/
AGAPE/
GAIA

Lying on the beach that one
moment, mouth agape,
cheek and belly to sand,
my skin seemed to fly away
the way foam flies from water,
the way a curtain parts in a gust.

Where we touched, the earth's substance
and my own were no obstacle
to the continuity of the common space within,
and this is what Gaia taught me:

Alive as It is, Earth
feels no pain
at the gaping pit mine;
what looked to me like an open wound was more like a mouth.
My fear of Its ripping pain
was a disguise for my own sorrow,
for mourning my own
lost race, for the races and species
we've annihilated and continue to.

Those losses of ours,
dwarf the earth's.

Gaia will continue to spin
to harborto shudder
to engulf...........to give birth
and to take life deep within—later—to release—
Earth will continue to reflect to space
light as a glorious blue-green-white spinning swirl
radiating in every direction
—even, invisibly, from the night side—
in motion, recreated each moment.

Like the saint whose health the disciple worries about,
the earth does not need our sorrow.
We weep for ourselves,
for what we love and need
and destroy nonetheless

This does not mean we're alone.
It does not mean do not weep.

It means find what is precious
and bind it 'round with agape
drawn from the deepest of mines.

☀ *Karina Lutz*

TOGETHER

Nothing seems to change; we just get a little older
While our Southern states are growing colder.
We're too busy to worry about climate change…..
For most of us, it's out of our range.
Let's put our minds in motion, and stop polluting our
beautiful ocean.
Teach our young to preserve our land and lakes…..
A little guidance is all it takes.
If you see someone in need,
Don't think about it, just do a good deed.
Imagine if it were us on the street….
asking for change so we could eat.
Our natural resources must be preserved
for the next generation…..
We can't do it alone; we need every nation.
Ice is melting and our animals our dying
Let's make positive changes while the birds are still flying.
We are polluting our oceans without even a care…..
Our seafood is compromised and no one has fear.
The future depends on what we do today
composting and recycling
Read food labels and you'll never go wrong, your family
remains happy, healthy and strong
We are strong, resilient and can accomplish this
important task……..
"Let's work together to make our earth last!"

✺ *Vincent Pezzillo*

LEND A HAND (Song Lyrics)

Verse 1
Lend a hand to your neighbor
A smile to a friend
Bask in the glory and never let it end.
Time is such a treasure
Taken for granted
Like summer nights
And whispering winds
Whirling in a star filled sky

Chorus:
Suddenly the storm clouds pierce right through
Darkness blankets crimson sky.
Bursts of thunder lightning fill the air
Rushing water everywhere.
The streets soon look like rivers
Joy quickly turns to despair
Howling winds so deafening
People need help to survive

Verse 2
Lend a hand to build bridges
For all to cross.
Let's work together
Or all will be lost.
Time is so precious
This is the moment
For joining hands will make us strong
Lead us to a brand-new day.

Chorus
Listen well to the sparrow's call
Telling us of their plight
Angry winds stronger hurricanes
Make it hard for their flight.
Give voice to all the weary
They're all striving to survive.
Sing our song for all to hear
Let's keep our mission alive.

Verse 3
Lend a hand for our future
One dream at a time
Let's work together
And that mountain we will climb.
We are all earths' voices
All on one team
Spreading hope for everyone
Is how we'll succeed.
We're earth's voices
Working for our future.
Lend a hand.

☀ *Noreen Inglesi*

ONE HUNDRED YEARS

Picture—
horses and buggies
in dirt streets—
women in long dresses—
men in black hats.

Some one hundred years ago,
someone tore the reigns from us
and hid them at the tops of towers.
With electric light,
we went underground.

We're crawling out now
We're reaching around,
unlocking the lock.

Back in the sun,
we don't remember ourselves,
who we'd been,
who our greats had sweat
and prayed and pressed on for.
But the corporate skin sloughs off
more easily than we'd ever
imagined.

Some things are deadly serious,
but we forgot that
when "depression" and "anxiety"
replaced grief and toil.

I want a body beat limp
by its labor.

We trusted the
Great Brands to be our bodyguard.
From linoleum kitchen bunkers, collars starched,
we told our ancestors
it had all been worth it—
We had made it to Valhalla at last.
They died hoping we weren't
wrong.

You loaned it,
you lent it out,
the roots of life,
while you lived on
lattices of wire.
Climb down now—
your playground
is breaking anyhow.

Spout trash if you wish—
it doesn't mean
your roots are not inside you.
You've learned to suppress them,
but they're still there.

It's one of the only things I know.

Sit down at the dinner table
that is your whole
culture, your whole
family,
your whole location
in this network of the living and

Eat the air
Eat the flowers
Eat the seeds
Eat the leaves
Eat the earth
Eat—

until it is your turn to feed.

☀ *Sarah Moon*

BORN IN JANUARY

The wind bit your cheeks
A moon made of gold was caught
in branches black and bare

In your dream that night
you saw a parachute
And you knew it meant
you were free

Your children sleep
on either side of you now
The snow is your blanket
Looking ahead, into the distance
you see the new life
all in a halo

Everything that happens,
happens first in the dark

☀ *Sarah Moon*

THE COUNCIL
(THE ENVIRONMENT COUNCIL OF RHODE ISLAND)

This is the state, an old timer once advised,
where a young activist who as yet knows no one,
might stop the governor on the way to his car,

the SUV idling under the statehouse's marble portico
to whisk him away to the next event, say, Earth Day,
where he will smile

and still today it's true,
'though now it's a woman governor,
and a new young activist will smile
when she hears her words repeated
as if they were the governor's—

a brilliant idea, which in fact was honed at the Council
of the state small enough to gather monthly
every last little beach cleanup group
and alt-climate group all the way up to the oldest
land-and-water-protectors-who-started-as-birders group
(who still teaches our young to bird and to protect),

and includes the one remaining member of a committee
of a now-moribund all-volunteer once-mighty
group who spoke truth to power

while the other groups were too busy
and always, it seems, we have been too busy,
to see yet another thing that needs to be done

to stop the onslaught,
to stop the new way we've begun to kill
by accident, by denial, by uninformed greed,

for convenience sake. And so we need each other,
and face each other around tables as we have
since 1972, as in our small state it is convenient

and urgent to gather all who care.
And we still care enough to teach our young
to lobby and protect and ambush the good governor,

to teach our young and all within reach of those marble hallways
where people can still loiter in lobbies
and stalk the power and feed it its lines.

And sometimes, sometimes,
we unite for great change:
stop nuclear power plants,
stop mega ports and freeways,
restore brownfields and salt marshes,
clean water and air
and slow sprawl to a crawl.

Just see what can happen
with all of us.
All as one voice,
in council.

☀ *Karina Lutz*

Us and the Atmosphere

Here I stand at the edge of the earth, head in the clouds, feet in the dirt. Once again, I have been woken up to gaze at the sky. I cannot stare too long, as it overwhelms me.
Their beauty captivates my every being and leaves me short of breath

So I turn my face back to earth
The scenery, the greenery...
Green seems to be what everyone means
The leaves, the trees
They whisper to me like a mother
She tells me: 'Carry on my child. Your work is not yet done. Your journey has just begun. Sing in the silence, and dance in the rain. And don't mind the darkness when it's coming again.'

I hear her words flow through the trees and I feel the water under my knees. As I breathe, I can see the changing tides inside of me. I walk with Father sky and my spirit guides. I embody the change I wish to see. I embrace the shadow and light that radiates in and out of me.

I ask myself, where do we go from here? Is it just us and the atmosphere? Once again the words of the earth echo through the forest: 'Run from the wicked but remember the past. Know nothing is certainly going to last. Fight the toxic breeze, toxic air and authority that doesn't care.' Then she retreated back into the dirt. And Her sound ripples radiate to the ends of the earth.

Perhaps no one is really alone. To those who have a whole world in their head: Do not lose yourself in your tiny universe. You know who you are. So then Pursue your purpose. In this uphill battle you may be afraid, because no one is fearless. Then we must be brave. Listen to the Great Green Phantom Queen. She walks with you always, in your head and heart.

※ *Lee Wilder*

RESILIENCE

Resilience seeds itself deep in the mind.
Resilience holds fast
moving towards providence
anchored to every kind court of humanity
that names it unflagging name in battering winds
tosses the un-rescued ship of hope
into believing in deliverance.
Resilience lives
behind the ribs, guarding its bruises
on broken, homeless streets, or wherever it lives.
Resilience honors itself
through its decision to go on
prying through broken fields
and stunted plantings – tough
as a beautiful weed.
Resilience struggles to welcome rain
while it attends its un-promised flower.
But listen, the sea
sometimes has to speak
with stones in its mouth
trying to find a heartening voice.
And so resilience comes to shore
turning things over and
over again, scouring itself
with undercurrents of doubt.
But our sea will go on
braving whatever coast it meets
and kindness will remain resilient
as it somehow goes on thumping.

David Dragone

ADAPT

By the sea, I built a wall
Because I heard the sea was rising

The mighty ocean rose above it
She is powerful and strong

She brings storms that flood my roads
They intensify with each passing day

She brings higher temperatures that heat my skin
And confusion to her ecosystems

She sends salt through the roots of my plants
Drying out the last bits of life

For in this changing climate,
The ocean sees dead zones

The waters are rising
and the tides are changing

We must learn
We must adapt
We must all come together for a more resilient tomorrow

For my wall stood no chance

✹ *Nina Quaratella*

THE EARTH IS IN OUR CARE *(Song Lyrics)*

Verse 1
The future of our planet
Is a story to be told
Scientists hold the key
To changes that are bold
Electric cars with batteries
Protect the air we breathe
Solar panes will heat our homes
Sun's power's all we need.

Refrain
Stand up, reach out
Together we are strong
Let us use our voices
Singing in one song
Stand up, reach out
To people everywhere
Together we can do our part
For the Earth that's in our care

Verse 2
The land is our legacy
Preserved and specially shared
It's our job to nurture it
It's sacred for our air
When we walk upon it
Where acorns dress the ground
We'll try to be more frugal
And leave more than we found

Refrain
Stand up, reach out
Together we are strong
Let us use our voices
Singing in one song
Stand up, reach out
To people everywhere
Together we can do our part
For the Earth that's in our care

Verse 3
Wind energy converters
Fill our homes with light
Reducing need for fossil fuel
Helps make our future bright
Revitalizing neighborhoods
Or living off the land
Mindful of what's tossed away
Will make our future grand.

Refrain
Stand up, reach out
Together we are strong
Let us use our voices
Singing in one song
Stand up, reach out
To people everywhere
Together we can do our part
For the Earth that's in our care
This precious Earth is in our care.

✺ *Noreen Inglesi*

THE ARK: A NEW ARISING

It is a time of fever pitch,
A time when the very stitch-work appears unraveling
And signs of the Catastrophic are etched
Upon the face of the deep

I would build an Ark within my heart
Big enough to house the dream of Life
Strong enough to chart the seas of consciousness
Until our moment can be won

It would NOT be inspired by fear
Nor the wrath of God,
But by sorrow and by outrage
For a Race
Whose dual instincts shout
Both love and murder
Despite all gospels of restraint
A Race that finds itself knee-deep in furious undertows
Poised to slip back from Miracle
To the restless chant of Chaos

And yet, forged in the fires of necessity
You and I could build an Ark with limitless mind
Crafted from our humanity
Our most elevated moments
Of clarity
Of courage
Of compassion
That reveal
The vast, agonized beauty embedded
Within our thwarted destiny

It would be fashioned
From artifacts of kindness:
A soldier's prayer for peace that still clings to a rusty nail,
A lullaby that drifts through open windows,
A choice of laughter against all odds,
A tear that dries quickly on the back of a hand,
A knee that bends before the grave of an enemy,
A greeting to a stranger through the mesh of a barbed wire fence...

It would be forged from
The cadences of heart and hand:
A shimmering note from Mozart
A word from Shakespeare
A brushstroke of Van Gogh...
A million artists' cries of astonished beauty
That rise stubbornly
Above the refrain of war and poverty

And the incandescent visions
Seeded in our souls
By Martin Luther King
And Gandhi
And the dense, considered silence of monks
Who gaze out upon the world From snow-shrouded caves

All the indelible footprints
Left in History's anonymous sands
Of those who gave their lives in service to others
That neither wind nor time can erase

As we each dream this Ark
The synergy of thought will find momentum
In kindred souls
Who have been battered by perception
And summoned to the sea as well

And as we work together,
We will find ourselves connected
And as we create,
We will discover the light within our nature

And someday out along the borders
Where Thought collaborates with Matter
The fever will break......
And the rising waters recede.......
We will witness our Human Ark become resolute
And of this Earth
Anchored in the dream of Creation
That moves through each of us
Like a wind about the stars

✺ *Thomas Lane*

POLAR PURGE

All I see is desolation,
As my icy scape turns to mush.
The seals seemed to have already made the revelation,
As thick ice turns to slush.

The time we have is running out,
Not long before our extinction.
In my footsteps flowers seem to sprout,
Our frozen homeland has lost its distinction.

As the days seem to be getting warmer,
I find there is no way for me to shed my coat.
As days go by I start to feel like a foreigner,
I wish I could find the antidote.

Although in these times not all is lost,
Within the puddles is a glimmer of hope.
Eventually in time we'll regain our frost,
But until then we'll just have to cope.

※ *Isobel McConnell*

SURVIVAL IN THE SMOG

Changing climate plagues
Air and water as we speak
We must save our world
From a future oh so bleak.

Installations of the panel
Harness power from the sun,
Solar energy they channel
Shows the smog it hasn't won.

We must use the right solutions
To cease disease from pollution
So we can mitigate the sorrow
And look upon a bright tomorrow.

❄ *Jonathan Teodros*

EARTH

The big land and bodies of water,
It's beautiful trees,
Flowers, grass,
and
natural resources surrounding us.
It provides us with anything
And everything we need.
Without it,
We are nothing.
So many beautiful things and places to explore.
It needs our care,
it provides us with so much
And
So many beautiful things we can admire from it.

�֎ *Melanie Morales*

TREES...WONDERFUL TREES

Trees…..Wonderful trees
They bend and blow in the breeze
Trees…..Oh wonderful trees
Without them where would we be?
No shade in the summertime,
No warmth in the wintertime,
No insects for the birds to peck,
No place for the squirrel to build his nest.
There would be no wood to build a fire.
No beauty in the fall months either.
Oh trees, oh wonderful trees,
Without them where would we be?

✺ *Valerie Davis*

RESILIENCE

Recovering quickly, resolved she stands to reach the sky after recurring rains soak in; retaining midst remote rugged rocks.

Entangled, sometimes exhausted and empty; established though with an elastic entity exists with exhilaration; effectively escapes the enemy, the elements-elevated like an elite eagle examining its environment.

Scarred snarly branches, safe and secure she slowly sways 'neath stormy skies; shimmering supple leaves sing softly shielded from searing scorching sun's rays.

Intensely insulted, standing irately isolated illuminating the mountainside, impressive and irrevocable, leaving an impenetrable indelible imprint.

Licking the landscape at times, she appears lame, limp and languid; literally struggling with labors of life, while lingering limitlessly with luster.

Inch by inch with illogical initiative, immense she stands – internally immune, inevitable inspiration, always ingrained with integrity.

Encircled and exiled, each root extraordinarily envelops the expanse, entrapping the earth, preventing erosion with elegance.

Notice how she narrowly leans nestled with nerve, nearly into nothing; negated and nurtured with native, natural nourishment, always navigating her niche.

Challenging one's character, the camouflaged cedar in Creator's care, celebrates if chafed or cramped in crisis, colliding with calamity; carefully maintains control; courageously capable; coping with calm and certainty.

Exhausted, on edge, sometimes enslaved and enfeebled –every moment equipped with exemplary effort; overcome with energy evidently engrossed, empowered and entirely engaged with exemplary esteem!

✺ *Sharon E. Alexander*

PUSH-ON

Lungs are stricken with black
If we could we would take it back
But we can't so push on
Children struggling to breathe
And they just started to teeth
But still, we must push on
Moving forward through the black
No way we are going back
But we pushed on
The earth will look anew
When our dreams come true
Because we pushed on
Lush Greene as far as we can see
That's from you and me
Because We Pushed On
What a day it will be
when we see our kids play free
Because
We
Pushed
On
Though the grime
Built over time
Through the ups and the downs
We will turn our world around
It will look brilliant
Because we are resilient
And We Pushed On

�֍ *Sean Hardison*

BEYOND RECYCLING

You and I may clean and recycle all day long,
But are we doing it right? Did you know many recycle wrong?
Just one wrong item, like foil or broken glass,
Can contaminate recycling, the entire batch.

When our recyclables are picked up by a truck,
They are brought to a facility and all sorted out.
If contaminated with a coated receipt or dog poo (yuck),
All other items in the batch are literally thrown out.

If we reduced our huge landfills by recycling properly,
More recycled goods would be made with much less energy.

Since 1970, we've celebrated Earth Day,
"Reduce, Reuse and Recycle," is what they say.
However, with no universal recycling standards or regulations,
Each city and state set their own limitations.

Recycling has declined in our Country for years,
And it's not because we, as individuals, don't try or don't care.
It's because some cities and states were not regulating things well,
And it costs money to clean contaminations, so it ended up in landfills.

Although 100% of our recyclables are not guaranteed to be used,
That's ok, because like economics, supply and demand remains true.
Our federal government does need to step up,
And enhance the mechanics of recycling, too.

As dedicated citizens, doing our part is on us.
We must not think that recycling is enough,
In fact, reducing and reusing is just as important.
When we go to a store, we must not bluff,
We must pay attention to the material of our stuff!

In the end, recycling paper or bottles are still crucial,
Resources went into making the object, if reusable.
If recycling paper saves trees, as we've heard,
Imagine a world where needing paper was absurd.

Continue to recycle, reduce and reuse whenever possible -
be an inspiration,
It is up to us, after all, to leave a sustainable world -
for our next generation.

Shalissa Coutoulakis

A THIRST FOR SUMMER

Summer Sun, shine deeply into my flesh.
Beach sand, blow with the wind,
Sprinkle grains against my cheeks.
Roar, Ocean!
Crash against the rocky shore and
Bathe me with your brine.
Let me taste your strength
Then feel your calm
Quiet withdrawal.

Peg Paolino

RESILIENCE OF WISDOM

A farmer walks along the lines that are left behind by his tilling.
The composition of the soil is of recycled matter from yesteryear's harvest,
In which the roots of the new plants will plunge deep into their origin,
Sustaining off of the history that their ancestors produced.
Living through the influence of ancient knowledge, building resilience,
So that their blossoms may never whither,
and sustain in one's mind an image of brilliance.

The farmer sits under the gargantuan trunk of an ash tree,
His cap over his eyes, as he takes a resting position, a bough as his bed.
He has worked hard this day, and sees fit that the product is to his content.
Organic are his methods of agriculture, and indeed, his ideas, too.
And never he worries about the industrial bustle,
though this does take great skill,
The wisdom and cunning he gains is immense, as he hangs on Yggdrasil.

✺ *Teagan Smith*

THE POTATO

The first harvest rolls in the basket
as the man walks in from the garden
Between his thumb and finger,
he shows her a potato the size of a grape
The hearkening of yield
She takes it, puts it in the soup
and tells her friends
"Elwood grew the potato"

In July and August they dig three times,
making dirty piles
for the old covered chamber pot
perfect for dry, dark, cool storage
She looks into the eyes of the potatoes
and, for the first time,
meets her food face to face

The corn is a second story
After much reading and discussion in the winter
he has planted four rows
The leaves gloriously saw in the waning summer
Kernels swell on the cobs
She leaves trails of husk and hair
from garden to kitchen
And whispers to the ears
"Beautiful"

Cucumbers sprawl spiny and sweet
Weeds from manure's mystery seeds
rise high above intended plants
Green tomatoes dip cockeyed into the soil
The pumpkins have become perfectly orange
long before Halloween
 "Some beetle," he says,
 examining beets and skinny onions

She has pickled three quarts of peppers today
blanched and frozen the corn
placed wiry goosenecked garlic foliage
on the counter
which has been cut by known hands,
grown in known soil

feet away from the kitchen, the mouths
This is suburban flight
family reunion
reconciliation
a rebuttal to progress
food of one's own

✺ *Aubrey Atwater*

WE WALK ON THESE
TREASURED LANDS

We walk on these treasured lands
Preserved and shared by
Someone who saw this lanky oak
And berries bright
As sacred gifts for all to behold

Here on this path of hidden wonders
We can toss out the day's burdens
And cleanse our lungs
With long awaited crisp fresh breath
Soaking in the soft, soothing sunlight
Sometimes difficult to see
When standing amidst
Rows and rows of towering hickories

Each tree, whether pine, oak or chestnut
Speaks of a story
Through trunk, bark or bough
Of triumph and resilience
Standing tall and oh, so eloquently
Through years of tempests' might
Or fiery plight
Or even the not so gentle touch
Of a woodpecker's delight

We gratefully walk on this land
Where acorns, berries and pinecones abound
Adorning the ground
Like a blanket
Wrapped delicately around a newborn
For the first time
A feast for our eyes

And a bountiful banquet
For the creatures
Who seek shelter here
Build their nests
And securely nestle themselves
Within the burly branches and shrubs

We walk on these lands
Mere tenants in these timeless groves
Where tender fawn peeks out
Through patches
Of forsythia in early bloom
And where the scent of pine
Makes itself known
And where the sparrow and robin
Share their glee harmoniously
As they bask in the gentle mist
Of early morn

We walk these lands
Legacies unselfishly bestowed
With forethought and generosity
Emanating pride and hope
Through planting,
Protecting and nurturing
These bountiful acres
Surely helping
To sow the seeds
Of tomorrow.

※ *Noreen Inglesi*

THE WHIRLY BIRDS

When I was a just girl and free from stress I used to play,
Out in the yard, I'd run around and dream the day away.

And sometimes in the springtime when the seeds of trees would fall,
I'd gather them together in a pile and have a ball.

I'd look inside inspecting them and stick them on my nose.
I'd wonder who created them in thoughtful deep repose.

I'd lay and watch the wind as it would gently coax them free,
From bonds that kept them closely bound to branches on the tree.

"Come follow me," the wind would call. "Come fly and spin with me.
I'll take you for a ride and show you magic sights to see!"

Some feared the wind and holding fast refused to just let go.
They clung in fear to mother's branch the world they'd come to know.

But others who relinquished bonds would float upon the air.
They'd spread their wings and twist and dance and sing without a care.

Exhilaration, wonder at a world they saw below.
Excitement filled them as they'd gasp at life's great magic show.

A lucky few would meet the earth to ripen in the sun.
They'd shed their coats and growing roots a new life had begun.

We all must search for courage to become what we can be.
To suffer as we grow and learn with all we come to see.

In search of bright tomorrows, dreaming dreams to pacify,
The fear we all must challenge as we spread our wings to fly.

And reaching toward the sun we'll soar because we know it's true,
That anything is possible if you believe in you!

✺ *Janet Barron*

ENVIRONMENTAL AGENCIES

The American Lung Association in R.I.

Our mission is to save lives by improving lung health and preventing lung disease. Our vision is a world free of lung disease. Our strategic imperatives are to defeat lung cancer, to improve the air we breath so it will not cause or worsen lung disease, to reduce the burden of lung disease on individuals and their families, to eliminate tobacco use and tobacco-related diseases and to accelerate fundraising and enhance organizational effectiveness to support the urgency of our mission.

260 West Exchange Street, Suite 102B
Providence, R.I. 02903
Phone: (401) 533-5179
Website: www.lung.org
Contact: Jennifer Wall
Email: Jennifer.Wall@lung.org

Appalachian Mountain Club

The goal of the AMC is to promote the protection, enjoyment and wise use of the mountains, river and trails of the Northeast.

130 Sudbury Street, Providence, R.I. 02908
Phone: (401) 351-2234
Website: www.outdoors.org
Contact: Linda Pease
Email: linda.pease@cox.net
Volunteer Opportunities: Clear and cleanup trails.
Contact: Linda

Blackstone River Watershed Council

To restore, enhance and preserve the physical, historical and cultural integrity of the Blackstone River, its watershed and its eco-system, through public advocacy, education, recreation, stewardship and the promotion of our unique Blackstone Valley resource.

Mailing Address:
P.O. Box 8068, Cumberland, RI 02864
Phone: (401) 723-8828
Website: www.blackstoneriver.org
Contact: John Marshland
Email: BRWCFOB@gmail.com

Friends of Blackstone River Environmental Center

100 New River Road, Lincoln R.I. 02865
Volunteer opportunities: Clean up and evasive plant control
Contact: Keith Hainley, Director, River Restoration
Phone: (401) 724-5292

Blackstone Valley Tourism Council

To inspire and increase sustainable tourism in the Blackstone River Valley.
175 Main Street, Pawtucket, R.I. 02860
Phone: (401) 724-2200
Website: www.blackstonevalleytourismcouncil.org
Email: info@tourblackstone.com
Volunteer Opportunities: To keep Blackstone Valley beautiful.
Contact: Donna Kaehler
Email: keep@tourblackstone.com

Childhood Lead Action Project

The Childhood Lead Action Project's goal is to eliminate childhood lead poisoning through education, parent support and advocacy.
1192 Westminster Street, Providence, R.I. 02909
Phone: (401) 785-1310
Website: www.leadsafekids.org
Contact: Laura Brion
Email: info@leadsafekids.org
Volunteer opportunities: Advocacy and outreach

Citizen's Climate Lobby R.I. Chapter

A non-profit, grassroots advocacy organization focused on national policies to address climate change. We train and support volunteers to reclaim their democracy and engage elected officials and the media to generate political will for solutions that will stabilize the earth's climate.
P.O. Box 523, Jamestown, R.I. 02835
Website: www.citizensclimatelobby.org
Contact: Peter Trafton
Email: peter_trafton@brown.edu

Climate Action RI

The increasing destabilization of Earth's climate due to fossil-fuel combustion is a scientific fact and a threat to our collective well-being. In light of this threat, our Organization's mission is to change the way our society creates and uses energy, focusing on the elimination of fossil fuel extraction and use, and the way we work together in anticipation of climate change. We do this work through vivid, nonviolent actions that stimulate public engagement; direct communication with stakeholders and legislators; and mutual support with other organizations whose missions overlap our own. We are committed to climate and environmental justice across all sectors to foster a healthy and equitable society

Phone: (401) 440-0665

Website: www.world.350.org/rhodeisland/

Contact: Nicole DiPaolo

Email: nicolelenadipaolo@gmail.com

Volunteer opportunities: making art, knocking on doors,

lobbying legislators and coordinating and participating in big events.

Earth Action

As a 501c4 non-profit organization, Earth Action takes a greater approach in implementing Earth Ethics mission by involving ourselves in advocacy, lobbying, and political activity. With Earth Action we strive to change current political regulations and push for policies that take into consideration the welfare and safety of the environment.

Phone: (850) 549-7472

Website: www.earthethics.us

Contact: Mary Gutierrez, Executive Director

Email: earthethicsaction@gmail.com

Volunteer Opportunities: The responsibilities will be varied and include meetings, conferences and representation at local, state and regional levels.

Contact: Mary Gutierrez

Earth Ethics

The MISSION of Earth Ethics is to educate the public and increase awareness about environmental and social justice issues at local, regional, and global levels in an effort to engage, empower, and encourage public involvement towards positive resolutions.

Phone: (850) 549-7472
Website: www.earthethics.us
Contact: Mary Gutierrez, Executive Director
Email: earthethicsaction@gmail.com
Volunteer Opportunities: Responsibilities will be varied including meetings, conferences and representation at local, state and regional levels.
Contact: Mary Gutierrez

Environmental Justice League of R.I.

To promote safe and healthy environments for all by building power, leadership and action in the communities most affected by environmental burdens. EJLRI envisions a R.I. where we all have a healthy place to live, work and play regardless of race, ethnicity, or income.

1192 Westminster Street, Providence, R.I. 02909
Phone: (401) 383-7441
Website: www.ejlri.org
Contact: Steve Roberts, Organizing Director
Email: steve@ejlri.org

Filarski/Architecture + Planning + Research

We are an integrated architecture, design and planning, ecology studio and research workshop. The studio has been recognized with national, regional, state, and local awards in architecture, planning, urban design, and sustainable building/ ecological systems research from professional societies, government agencies, and citizen organizations. The studio and workshop is dedicated to innovation and excellence in design and planning creating a working landscape of ecology directed toward social responsibility and stewardship, lifelong learning, sustainable and renewable environments, and appropriate technology and economics in our urban, rural, coastal, corporate, and ecological communities.

P.O. Box 3210, Providence, RI 02909
Phone: (401) 331-8800
Contact: Ken Filarski
Email: kjfilarski@yahoo.com
Volunteer opportunities: Grant work, etc.

Green Circle Design

Sustainable landscape architecture.
286 Rochambeau Avenue, Providence, R.I. 02906
Phone: (401) 421-9599 or (401) 996-4922
Website: www.Greencircledesign.net
Contact: Kate Lacouture
Email: kate@greencircledesign.net

Green Energy Consumers Alliance

We enable everyday people to make green energy choices in the most cost-effective, practical and seamless ways possible, and to advocate for energy policies that benefit the greater good.
2 Regency Plaza, Suite 8, Providence, R.I. 02903
Phone: (401) 861-6111
Website: www.greenenergyconsumers.org
Contact: Priscilla DeLacruz
Email: Priscilla@greenenergyconsumers.org
Volunteer opportunities: part-time interns.

Greene School (The)

The Greene School explores the interdependence of human and natural systems. Through a rigorous pre-college curriculum, we develop citizens and leaders engaged in finding peaceful and sustainable solutions to local and global challenges. We are located on 70 acres of natural forest in West Greenwich, R.I..
94 John Potter Road, Unit 3, West Greenwich, R.I. 02817
Phone: (401) 397-8600
Website: www.tgsri.org
Contact: Joshua Laplante, Head of School
Email: jlaplante@thegreeneschool.org

Institute at Brown for Environment and Society (IBES)

With a changing climate and growing population, our fragile planet is at risk. Today's complex global changes call for innovative thinking. Business as usual is no longer effective. To work toward an equitable and sustainable future, Brown University launched the Institute for Environment and Society (IBES) in 2014. An education and research hub, IBES harnesses academic excellence from many disciplines, including climatology, sociology, ecology and economics. At this dynamic cross-campus center, students and faculty collaborate to discover, teach and learn at the crossroads of human aspirations and the environment that sustains us. Through a spirit of open collaboration, IBES is singularly poised to provide a concrete knowledge basis for informed decisions and to impact real-world policies.

Box 1951, 85 Waterman Street. Providence, R.I. 02912
Phone: (401) 863-3449
Website: brown.edu/environment
Email: environment@brown.edu

The Listening Tree Cooperative

Listening Tree Coop is a community of equality- and ecology-minded individuals, sharing meals, permaculture farming, hosting community events, and living cooperatively together in Chepachet, RI.

We are a cooperative household, incorporated as a limited equity housing cooperative to preserve farmland for farming, housing for people, and make it permanently affordable to do both here.

87 Reservoir Road
Chepachet, R.I. 02814
Phone: (401) 710-9784
Website: www.listeningtree.coop
Contact: Karina Lutz
Email: karinalutz@hotmail.com
Volunteer Opportunities: Interns for organic farming

Mercy Ecology

Our mission is to instill reverence for Earth and to work towards sustainability of life by acting in harmony with all creation.

15 Highland View Road, Cumberland, R.I. 02865
Phone: (401) 663-4530
ECRI Contact: Mary Pendergast, RSM
Website: www.mercyecology.org
Email: marypen211@gmail.com

Merlyn's Climate Grants

Merlyn Education and Climate Protection Project, known as "Merlyn Climate Grants," received its not-for-profit status in June 2019. Its mission is to mentor and support the efforts of exceptional young climate leaders, ages 13 to 30, living or studying in New England and New York.

11 South Angell Street, Unit 301, Providence, R.I. 02906
Phone: (401) 751-3766
Website: www.merlynspen.org
Contact: Jim Stahl
Email: grants@merlynspen.org

Nature's Trust RI

Nature's Trust RI is a youth-centered campaign to protect and enforce the legal right to a healthy climate for present and future generations.
52 Nichols Road, Kingston, RI 02881
Phone: (401) 871-1289
Website: naturestrustri.org
Statements from our Youth can be found at
http://naturestrustri.org/youth-and-young-adults-speak-out-2/
Facebook: www.facebook.com/NaturesTrustRI/
Email: NaturesTrustRI@pobox.com

Notable Works Publication and Distribution Co., Inc.

A nonprofit arts organization dedicated to raising awareness for environmental and social issues through the arts.
P.O. Box 8122, Cranston, R.I. 02920
Phone: (401) 585-4037
Website: www.notableworks.org
Contact: Bina Gehres
Email: binagehres@cox.net
Volunteer Opportunities: To assist with projects and events.

Protect R.I. Brook Trout

The establishment of Protect RI Brook Trout was motivated by a powerful interest in preserving, protecting, and restoring wild brook trout populations in Rhode Island. As concerned citizens, our goal is to advocate for ecologically-based management and enhanced conservation efforts for this state's only remaining wild and native salmonid.

Contact: Brian O'Connor
Email: oconnobri@gmail.com

Providential Gardener

Providential Gardener sees Rhode Island as a garden we all tend today so that future generations can enjoy living in this beautiful state. We focus on the question, Who does what to take care of R.I.? The website includes a comprehensive calendar of environment-related events (What Grows On in RI), a directory of organizations that take care of our environment, and news about RI's environment. All of this information is organized by more than 30 categories, including Climate.

P.O. Box 2556, Providence, RI 02906
Phone: (401) 273-6678
Website: www.provgardener.com
Contact: Susan Korte
Email: skorte@providentialgardener.com
Volunteer opportunities: Volunteers to promote our calendar and website at tabling events and for entering events into the calendar through the Add Event form:
https://www.provgardener.com/calendar/add-events

RI Association of Railroad Passengers

The RI Association of Railroad Passengers' goal is to improve the rail transportation system in R.I..
406 Stony Lane, North Kingstown, R.I. 02852
Phone: (401) 295-1311
Website: www.riarp.org
Contact: Everett Stuart
Email: evstuart@verizon.net
Volunteer opportunities: Rail policy, operations and work on the national level.

RI Committee on Occupational Safety and Health

R.I. Committee on Occupational Safety & Health (RICOSH) is R.I.'s best resource for workplace safety, health and injury prevention training and information.

741 Westminster Street, Providence, R.I. 02903
Phone: (401) 751-2015
Website: www.facebook/RICOSH
Contact: Jim Celenza
Email: jascelenza@gmail.com

RI Interfaith Power and Light

RI Interfaith Power and Light inspires and mobilizes people of faith and conscience to take bold and just action on climate change.
P.O. Box 8815, Warwick, R.I. 02888
Phone: (401) 324-9142
Contact: Katherine Gibson
Email: kmg4612@verizon.net

Sunrise Providence

Sunrise Providence is a youth movement to stop climate change and create millions of good jobs in the process.

Phone: (401) 484-1395
Website: http://sunrisepvd.com
Facebook: http://www.facebook/SunriseRhodeIsland/
Email: sunriseprovidence@gmail.com

Buckeye Brook Coalition

Protection and restoration of Buckeye Brook and its tributary streams and watershed.

P.O. Box 9025, Warwick, R.I. 02889
Phone: (401) 739-6592
Website: www.buckeyebrook.org
Contact: Michael Zarum
Email: located@rcn.com
Volunteer opportunities: Seasonal for fish count and clean up.
Contact: Paul Earnshaw
Email: brookeye10@gmail.com

Environment Council of R.I.

We are a coalition of organizations and individuals. Our mission is to serve as an effective voice for developing and advocating policies and laws that protect and enhance R.I.'s environment. We are proud of our long history of environmental advocacy dating back to 1972.

P.O. Box 9061, Providence, R.I. 02940
Phone: (401) 621-8048
Website: www.environmentcouncilri.org
Contact: Greg Gerritt
Email: environmentcouncil@earthlink.net
Volunteer opportunities: Seeking people to speak out on legislation
and policy at the R.I. State House.

RI Bicycle Coalition

Our mission is to cultivate a physical and social environment in R.I. that encourages bicycling for all ages.

P.O. Box 2454, Providence, R.I. 02906
Phone: (401) 297-2153
Website: www.ribike.org
Contact: Kathleen Gannon, Chairperson
Email: treasurer@ribike.org
Volunteer opportunities: Volunteers needed for events.

RI Environmental Education Association

RIEEA is a network of professionals and organizations committed to promoting high-quality environmental education that increases the environmental literacy of all children and adults in our state. Our membership includes teachers, naturalists, environmental organizations, and educators from universities, recreation centers, and state, federal, and non-profit agencies, among many others. We foster collaborations, sponsor professional development opportunities, gather and disseminate information on environmental education, and promote public understanding of the value of an environmentally literate citizenry.

P.O. Box 40884, Providence, RI 02940
Contact: Jeanine Silversmith
Email: info@rieea.org
Website: rieea.org

RI Land Trust Council

The R.I. Land Trust Council's purpose is to foster a sustainable land conservation movement in R.I. by supporting the missions and operations of land trusts and providing a forum for their effective cooperation. These land trusts seek to preserve open spaces, natural areas, scenic character, watersheds, drinking water sources, farmland, forests, historic sites, and shorelines that uniquely define our communities. Collectively, we are preserving the heritage of our state for future generations.

P.O. Box 633, Saunderstown, R.I. 02874
Phone: (401) 932-4667
Website: www.rilandtrusts.org
Contact: Rupert Friday, Executive Director
Email: rfriday@rilandtrusts.org
Volunteer opportunities: Clear trails.

American Chestnut Foundation, MA/RI Chapter

The MA/RI Chapter of the American Chestnut Foundation is dedicated to restoring the keystone forest tree of the east by breeding local American chestnut "Mother" trees into a population of blight-resistant trees.

209 Richardson Street, Oxbridge, MA 01569-1621
Phone: (508) 278-3565
Website: www.acf.org
Contact: Yvonne Federowicz
Email: Yvonne.federowitz@gmail.com

Aquidneck Island Land Trust

Our mission is to preserve and steward Aquidneck Island's open spaces for the lasting benefit of the community, while connecting people with the land that defines the Island's natural character.

790 Aquidneck Avenue, Middletown, R.I. 02842
Phone: (401) 849-2799 ext. 18
Website: aquidnecklandtrust.org
Contact: Laura Freedman Pedrick
Email: lpedrick@ailt.org
Volunteer opportunities: If people want to volunteer, they may go
to this page on our web site and complete the form:
https://ailt.org/ways-to-give/volunteer/

Audubon Society of Rhode Island

The purposes of the Audubon Society of Rhode Island are to foster conservation of wild birds and other animal and plant life; to conserve wildlife habitat and unique natural areas through acquisition or other means; to carry out a broad program of public conservation education; to focus public attention on natural resource problems; to provide leadership when action on natural resource problems is necessary, and to do all other things necessary to foster better management of the natural environment for the benefit of humans and all other life.

12 Sanderson Road, Smithfield R.I. 02917
Phone: (401) 949-5454
Website: www.asri.org
Contact: Meg Kerr
Email: mkerr@asri.org
Volunteer opportunities: Please check website.

Burrillville Conservation Commission

The Burrillville Conservation Commission's mission and goals are to protect and preserve the natural tranquility of the natural reserves, features and attributes that has defined the Town of Burrillville for over two hundred years.

105 Harrisville Main Street, Harrisville, R.I. 02830
Website: www.burrillville.org
Contact: Richard Dionne
Email: rdionne99@aol.com

Clean Ocean Access

The mission of Clean Ocean Access is to "take action today so future generations can continue to enjoy ocean activities." Our main programs are CLEAN (removing marine debris from the shorelines and changing human behavior to eliminate trash on the shoreline and in the ocean), OCEAN (permanent year round clean water on our shorelines) and ACCESS (make sure public access is and shoreline habitat is available and protected forever). We have a focus on Aquidneck Island and work off the island with partner organizations as required to achieve our goals.

21 John Clarke Road, Middletown, RI 02842
Website: www.cleanoceanaccess.org
Contact: Dave McLaughlin
Email: info@cleanoceanaccess.org or dave.mclaughlin@cleanoceanaccess.org
Volunteer opportunities: Listed on website.

Clean Water Action

The goals of Clean Water Action are clean, safe, and affordable water, clean up of toxic waste and aiding in the solid waste crisis of composting and recycling in market development.

60 Valley Street, Suite 101, Providence, R.I. 02909
Website: www.cleanwateraction.org
Contact: Jonathan Berard, State Director
Phone: (401) 331-6972
Email: provcwa@cleanwater.org

Common Fence Point Improvement Association

The Common Fence Point Improvement Association was formed to protect and maintain property and buildings held in trust including beaches, right of ways, playgrounds and salt marshes.

933 Anthony Road, Portsmouth, R.I. 02871
website: www.commonfencepoint.org
Volunteer opportunities: Help with events, clearing and mowing.

Grow Smart R.I.

Grow Smart R.I. provides statewide leadership for diverse public and private interests seeking sustainable and equitable economic growth. We promote such growth by advocating for compact development in revitalized urban, town, and village centers balanced with responsible stewardship of our region's natural assets – farmland, forests, the coastline, and the Bay. We inform leaders, decision makers, and concerned citizens about the many benefits of compact development and asset stewardship and provide research and training on proven smart growth strategies. We convene broad coalitions that advocate policy reforms and specific projects designed to build communities where all people and businesses can thrive.

1 Empire Street #523, Providence, R.I. 02903
Contact: Scott Wolf (401) 273-5711, ext 101
Contact: John Flaherty, Director (401) 273-5711, ext 102
Website: www.growsmartri.org
Email: swolf@growsmartri.org
Email: jflaherty@growsmartri.org
Volunteer opportunities: Assisting in policy research, data base updating, event support.

Groundwork Rhode Island

Our mission is to reconnect the fabric of urban communities by meeting the dual needs of environmental sustainability and economic prosperity in partnership with community residents, businesses, and other partners.

1005 Main Street #1223, Pawtucket, R.I. 02860
Phone: (401) 305-7174
Website: www.groundworkri.org
Contact: Amelia Rose
Email: arose@groundworkri.org
Email: info@groundworkri.org

Narragansett Bay Estuary Program

Our mission is to protect, restore, and preserve Narragansett Bay and its watershed. The Narragansett Bay watershed is over 1 million acres in area and is home to almost 2 million residents from Rhode Island and Massachusetts. We collaborate with organizations from both RI and MA who work to protect wildlife, ensure water is safe and clean, and promote community involvement.

235 Promenade Street, Suite 393, Providence, R.I. 02908
Contact: Mike Gerel, Program Director
Phone: (401) 633-0550
Website: www.nbep.org
Email: info@nbep.org

Narrow River Preservation Association

The Narrow River Preservation Association (NRPA) works to preserve, protect, and restore the natural environment and the quality of life for all communities within the Narrow (Pettaquamscutt) River Estuary and Watershed.

P.O. Box 8, Saunderstown, R.I. 02974
Website: www.narrowriver.org or nrpa@narrowriver.org
Phone: (401) 783-6277
Contact: Nate Vinhateiro
Email: nvinhateiro@gmail.com or nrpa@narrowriver.org

Save The Bay

The Mission of Save The Bay is to protect and improve Narragansett Bay.
100 Save the Bay Drive, Providence, R.I. 02905
Phone: (401) 272-3540
Website: www.savebay.org
Contact: Jonathan Stone, Executive Director
Email: mcrowley@savebay.org
Volunteer opportunities: Intern and volunteer opportunities.
Email: volunteer@savebay.org

Sierra Club Rhode Island

The Sierra Club Rhode Island's goal is to preserve, enjoy, and protect our environmental resources.
118 Gano Street, Providence, R.I. 02906
Website: www.sierraclub.org
Contact: Aaron Jaenig
Email: chair@risierraclub.org

South Side Community Land Trust

Southside Community Land Trust provides access to land, education and other resources so people in Greater Providence can grow food in environmentally sustainable ways and create community food systems where locally produced, affordable, and healthy food is available to all.

109 Somerset Street, Providence, R.I. 02907
Phone: (401) 273-9419
Website: southsideclt.org
Contact: Margaret De Vos
Email: margaret@southsideclt.org
Volunteer opportunities: Farm work
Contact: Agnieszka

The Nature Conservancy in Rhode Island

The Nature Conservancy in Rhode Island is part of an international non-profit organization with a single goal: Preserving rare and endangered species through the protection of the ecosystems that sustain them. More than 4,000 acres of RI land have been protected by the Conservancy since the early 1960's.

159 Waterman Street, Providence, RI 02906
Phone: (401) 331-7110
Website: www.nature.org
Contact: John Torgan
Email: jtorgan@tnc.org

West Bay Land Trust

The Mission of The West Bay Land Trust is to maintain a rich blend of wetlands, woodlands, urban preservation and pastoral space in the city of Cranston. Our goals include sustaining the working farms in the rural, western area of the city, as well as preserving the diverse nature of all Cranston's communities, thus allowing the city to offer a continued variety of residential lifestyles to its citizens.

P.O. Box 2205, Cranston, R.I. 02905
Phone: (401) 461-6426
Website: www.westbaylandtrust.org
Contact: Doug Doe
Email: dirdoe@cox.net

Westerly Land Trust

The Westerly Land Trust, a not-for-profit corporation, operates throughout the town to preserve and enhance Westerly's sense of place. The Trust works to preserve open space, rehabilitate and renew older neighborhoods, and create educational and recreational opportunities for the public. Our programs and activities are designed to enhance our town's urban landscape as well as its natural environment, wildlife habitats, native plants, and water resources.

P.O. Box 601, Westerly, R.I. 02891
Phone: (401) 315-2610
Website: www.westerlylandtrust.org
Contact: Jennifer Fusco, Executive Director
E-mail: info@westerlylandtrust.org
Volunteer opportunities: Trail maintenance, event volunteers,
community gardening work, urban co-op and farmers' market.

Wood-Pawcatuck Watershed Association

WPWA's goal is to ensure protection of the natural and historic areas of the watershed. Activities include: the River Captain Program and the Watershed Watch Program to build a base of information from visual observation of changes and weekly analysis of samples, the Pawcatuck Estuary Planning Project, an Environmental Fair for schoolchildren, clean-ups, canoe trips, and public forums.

203 Arcadia Road, Hope Valley, R.I. 02832
Phone: (401) 539-9017
Website: www.wpwa.org
Contact: Chris Fox
Email: chris@wpwa.org
Volunteer Opportunities: Via website

Woonasquatucket River Watershed Council

In 1998 the Woonasquatucket River was designated as one of fourteen American Heritage Rivers. This federal designation honors the historic, cultural, economic and environmental significance of this R.I. treasure. The Woonasquatucket River Watershed Council (WRWC) protects and restores the urban river, as well as park spaces and a bike path directly alongside the river. WRWC runs many programs – Clean Days on the Greenway volunteer events, water and fish monitoring, bike and education lessons and activities, recreation events and more.

45 Eagle Street, Suite 202
Providence, R.I. 02909
Phone: (401) 861-9046
Website: www.wrwc.org
Contact: Alicia Lehrer
Email: alehrer@wrwc.org
Volunteer opportunities: Seeking help with clean up efforts.

Environmental Protection Agency (EPA) in R.I.

27 Tarzwell Drive, Narragansett, R.I. 02882
Phone: (401) 782-3000
Website: www.epa.gov/ri

R.I. Department of Environmental Management

Rhode Island Department of Environmental Management serves as the chief steward of the state's natural resources – from beautiful Narragansett Bay to our local waters and green spaces to the air we breathe. Our mission put simply is to protect, restore, and promote our environment to ensure R.I. remains a wonderful place to live, visit, and raise a family. We protect these precious resources through development and enforcement of environmental laws, and we strive to provide guidance to our many customers in complying with these laws. We work with our partners to restore our lands and waters, to conserve wildlife and marine resources, and to monitor environmental quality so we can build healthy, more resilient communities. We promote our natural resources – from our historic parks and beaches to our farms and delicious local food and seafood. We are focused on helping our state grow "green" and build desirable neighborhoods that offer ample space to recreate and connect with nature.

235 Promenade Street, Providence, R.I. 02908
Emergency after hours: (401) 222-3070
Narragansett Bay Line: (401) 222-8888
Contact: Suzanne Amerault, Director, Suzanne.Amerault@dem.ri.gov
Phone: (401) 222-4700 Ext. 2409
Website: www.dem.ri.gov

CONTRIBUTING POETS

THE CONTRIBUTING POETS

Sharon E. Alexander

Sharon E. Alexander, a Narragansett Indian, who grew up living off the land, was born and raised in Washington County, RI observing firsthand, the devastating effects of pollution, toxic waste, a nuclear power plant now closed, and global warming. She has been described as 'a woman dedicated to her faith, being a mom, family, culture and career. Recently she was named 'The People's Poet', had one of her poems read and distributed at a graduation class and selected winner in a local contest.

Aubrey Atwater

From Warren, RI, award-winning multi-instrumentalist, vocalist, writer, radio commentator, and dancer, Aubrey Atwater presents unforgettable programs, singing and playing dulcimer, banjo, guitar, mandolin, and Irish whistle, and thrilling audiences with percussive dance. Aubrey's narrative work includes skilled stage patter, poetry and prose, as well as writing for public radio, magazines, blogs, and church services. Since 1988, Aubrey and her husband Elwood Donnelly have appeared throughout the US and beyond, producing thirteen recordings and six books. www.atwater-donnelly.com

Janet Barron:

As a 73-year-old grandmother of 10 and mother of 5, I have learned many lessons in life. These lessons have helped to inspire poems I write to share with people I know to help them celebrate a momentous occasion or to aid in comforting them. I currently work as a Teacher Assistant in a Cranston Middle School where I share my life lessons with the students.

Trent Batson

Trent Batson served as a university professor and administrator at 8 different universities before founding a global non-profit in 2009. While he has written poems for occasions over many years, he considered them as gifts to friends and family. The poem about Covid and Humans appeared one morning in his head and he simply wrote it down. He taught the first-ever academic course in ASL poetry, along with a deaf poet, Clayton Valli. His current work: www.thelasthumans.org

Elizabeth Bogutt

Elizabeth Bogutt is a member of the Guild writing group in Wakefield. Her poems have been published in several anthologies and she has been selected to participate in the annual Poets and Writers Exhibit at the Wickford Art Association for the last four years. Elizabeth has taught poetry courses for the OLLI at URI. Now retired, her career was in the field of mental health counseling.

Tessa Caporelli

My name is Tessa Caporelli. I am a 10th Grader at The Greene School in West Greenwich, RI. I really enjoy being busy and I participate in a variety of activities outside of school. One of my biggest passions is basketball. I LOVE playing basketball and getting to interact with other people. I spend my downtime hanging out with my dogs and looking up new places to travel with my family.

Chiara Conlon

Chiara Conlon is from Johnston, RI. Growing up in a family that is passionate about supporting the environment has given her the creativity and passion of protecting the environment. Chiara now attends The Greene School, an environmental charter high school in West Greenwich, RI. Her future goals and aspirations are to give back and try to make the world a better place.

Emily Joan Cooper

Emily Joan Cooper grew up in Wilmette, IL and has been a writer and diarist since she was little. She graduated with a B.A. from Bowdoin College in 2010 where she majored in Visual Arts. In 2019, she published a collection of poetry entitled *The Heart is a House,* available online through Barnes & Noble, Amazon, and Target. Cooper lives in Massachusetts with her husband Evan and their two dogs, Wendy and Hank.

Shalissa Coutoulakis

Shalissa is a strong and dedicated clinical social worker who strives to make an impact on all societal levels. Understanding that our environment impacts the life we live everyday, it is important to spread awareness about the small efforts we can take, which ultimately impacts all of us as a whole. I will always advocate for and support efforts that impact our psycho-social environment to ultimately make this world a safer and happier place to live.

Valerie Davis

Valerie Davis taught High School English for 20 years in Providence, RI. Survived a brain aneurysm in 2017 and retired in January 2020. Resides in Warwick, RI. If anything good has come from this pandemic, it is that pollution has gone down remarkably.

Nicole DiPaolo

Nicole DiPaolo, a white woman raised in rural RI, was privileged to cultivate an early passion for protecting nature. Now, a paid advocate, she is called to examine the collective sickness of the White Supremacy Culture of her upbringing in America, learning towards dismantling institutions systemically oppressing People of Color. Her commitment to reversing the narrowing possibility of a livable future, centers on justice for communities who, for centuries, have been robbed of a livable present.

David Dragone

David Dragone's poems and writings have appeared in Avocet, Bryant Literary Review, California Quarterly, Common Ground Review, Commonweal, Connecticut River Review, Oilheating Magazine, Providence Journal, Rhode Island Public Radio, Trinity Repertory Company, and elsewhere. He is the Editor-in-Chief of Crosswinds Poetry Journal. Crosswindspoetry.com. He tunes pianos and teaches violin.

Bobby Ferand

R. Forand released his first book, "Blame the Kennedys and Other Gifts," in 2017. He is a regular contributor to Motif Magazine and has had work published in Punkcake Zine and Wickford Art Association Poetry + Art. He is the drummer for The McGunks, Kuya and The Somethin' Somethings. He is slowly at work on his second collection, "Cardboard Nightmares," as well as a collection of ransom poetry, which is currently untitled.

Mary Gutierrez

Mary Gutierrez is an Environmental Scientist and Founder and Director of Earth Ethics and Earth Action. She is a poet, her first book "Naked in the Rain" was published in 2012. Several individual pieces have appeared in numerous zines and magazines over the years. Ms. Gutierrez is also an Ordained Minister and animal advocate. She is been a vegetarian for close to 45-years. Check out www.marytheauthor.com to see more of her work.

Noreen Inglesi

Noreen Inglesi, co-founder and Artist in Residence for Notable Works, taught music for the Town of North Providence and the Community College of Rhode Island for a number of years. She received her Master's Degree in Music Education and Composition at the University of Rhode Island. Noreen has received much recognition for her music and poetry, which has been featured locally by The American Band, The State Ballet of Rhode Island, The Colonial Theatre and Waterfire Providence. www.NoreenInglesi.com

Alex Kithes

Alex Kithes is a lifelong resident of Woonsocket, RI. His concern for the existential climate crisis grew out of a love for people, the planet, and social and economic justice. He is a climate activist with Sunrise Providence and Climate Action RI, and was elected in 2019 to the Woonsocket City Council. He maintains a holistic garden and a flock of chickens, and is an amateur writer and painter. Follow him @ AlexKithes on all platforms.

Thomas Lane

Growing up in Connecticut, Thomas Lane was deeply influenced by poet/singer-songwriters Bob Dylan and Leonard Cohen. Like them, he was drawn to landscapes where street and spirit intersect: relationships, civil rights, the search for higher ground. Trying to keep up with his muses, he has completed a CD of his songs **(Hotel Earth),** a book of poetry, and a screenplay – currently working its way through Hollywood. In addition, he has founded a 501c3 **HelenHudsonFoundation.org** that works with the homeless.

Jed Lee

Jed Lee is a Taiwanese and Chinese-Filipinx American student activist and artist currently living in Berkeley, CA. Jed is continuing studies in environmental, climate, and development justice at the University of California, Berkeley. Jed strongly believes that we can always look to nature to find inspiration for our collective movements and personal healing, and that there is always love, life and hope in this world.

Sarah Lettes

Sarah is an avid writer, runner, and public transit enthusiast. She is passionate about fighting for the people and places impacted by climate change. Eating a sandwich on top of a mountain is her favorite thing to do.

Jan Luby

Jan Luby is known for her engaging stage presence as well as a voice full of passion, range and power. Jan's original songs are evocative, lyrical, personal stories, ranging from socially relevant to irreverent. She connects with people whether performing to a large audience at a festival, or in an intimate coffeehouse setting, or heard by those nearby when singing from solitary confinement. She just released her 5th album, Night Window, in February and has gotten air play from New England to the west coast.
www.janluby.com

David Luken

David is a Rhode Island resident; a carpenter and promoter/installer of composting toilets by trade; a poet by impulse, always having loved the music in words, and by blood: both his parents are poets. This is his first published work of poetry.

Karina Lutz

Karina Lutz served as a sustainable energy advocate for three decades. "The Council" recalls the late 1990s, when as vice president of the Environment Council, she organized to stop the megaport at Quonset Point, restore wetlands along the Blackstone, build bike paths, improve transit and walkability, and curtail dumping of sewage into Narragansett Bay. She now carbon farms at her intentional community, Listening Tree. She recently had poetry books published: *Preliminary Visions* and *Post-Catholic Midrashim*.

Patricia MacAlpine

Patricia McAlpine is a poet & freelance writer currently residing in Warwick, RI. She has a BS in English from Northeastern University and has participated in several writing workshops and is coordinator of the Galway Kinnell Poetry Contest/Festival in Pawtucket. Bred in Lowell, MA, Patricia has a varied career history that includes, ranger/budget with NPS, substitute teacher, and river tour guide/educator. She is currently employed as Marketing Associate at Blackstone Valley Tourism Council.

Jim Manchester

Jim Manchester is a retired English/Theatre teacher. He has done voice over work for radio and TV spots and has worked as an audio book narrator. Poetry has been a passion for him for over fifty years and is humbled and honored to have his poetry shared and published. Jim resides in Bristol.

Mary Ann Mayer

Mary Ann Mayer's most recent book, *Kissing the Shuttle – A Lyric History* (Blackstone River Books) explores through verse, original voices, and historical research, the link between labor and health – specifically, cotton mills, the tuberculosis epidemic, and Rhode Island's public health vision. A retired occupational therapist, she is a member of the Ocean State Poets and also serves on the editorial team of *Crosswinds Poetry Journal.*

Chris Menton

Chris Menton is professor emeritus at Roger Williams University. He is a bicycle aficionado. He rides bicycles to get to work, to explore states and countries, to run errands and a number of other activities. He conducted the first research study of police bicycle patrols, is a nationally certified cycling instructor and a member of the Rhode Island Bicycle Coalition board of directors. He has designed innovative cycles and bikeways.

Sarah Moon

Sarah Moon is a community writing facilitator, playwright and scholar of rhetoric. Her poetry has been published in *Rosebud, Ampersand* and *Laurel Moon* and been awarded the Andrew Grossbardt Memorial Poetry Prize. Her plays have been produced in Boston, Washington D.C. and New York City. She is an Assistant Professor of Humanities at Massachusetts Maritime Academy and lives with her husband and two young children in Pawtucket, RI.

Nina Quaratella

Nina Quaratella is a passionate environmental educator with a focus on marine science, stewardship, and research. Nina is an Education Specialist with New England Science & Sailing, a non-profit organization that provides ocean adventure education programs to all walks of life. Here, she translates her love for coastal conservation into impactful education programs that combine marine science, adventure sports, and socio-emotional learning. She is excited to continue to write poetry to reflect her environmental activism.

Bryan Rios

Bryan Rios grew up as a child on The Palmas of Gran Canaria, Spain, and was born on February 11, 2004, at 14:45 p.m. He is known for his creativity when it comes to his poetry and his writing. He is currently a sophomore at the Greene School. Teachers may know him for his amazing way of speaking and for his incredible leadership ability.

Larry Robinson

Larry Robinson is a retired Eco psychologist and former mayor of Sebastopol, California. He is the founder and producer of Rumi's Caravan, dedicated to reviving the soul of the world through restoring the oral tradition of poetry. Water Shed is included in his collection *Roll Away the Stone*.

Fabian Torres

Fabian Torres is a sophomore attending The Greene School in West Greenwich, Rhode Island. He is from Pawtucket, Rhode Island. He is inspired by the work he does in school and his teachers as they always push him to be the best he can be. During his free time, he likes to do investing, write haikus and play basketball. His current goals are to finish high school and find an internship.

Mitch Weintraub

From RI, environmental science grad URI 2015, part time writer & speaker, can find me walking my dog Steve most of the time.

Lee Wilder

Is just a queer pagan loving the earth and the creatures that roam about here. A part of the environmental social justice movement and a member of Sunrise. A local musician, and honored to be a part of something so extraordinary. Follow me on Instagram for more antics if you wish @interstellar.yeller

Sandra Wyatt

"I grew up on 10 acres in Minnesota countryside in converted farm house on hill with woods and fields above and marsh/pond/puddle below — eighteen years of paradise. I moved to Allin's Cove in Barrington twenty-five years ago to find another kind of paradise. A new, beautiful and fascinating water body with complex issues becoming more so with climate change. Although short stories cover a gamut of milieus my poetry is almost all about what goes on outside my windows."

INDEX

SPECIAL THANKS TO NOTABLE WORKS' 2020 GOLD SPONSORS:

Aristocrat Dental Laboratory

Belmont Market

Captain's Catch Seafood

Bina Gehres

The Helen Hudson Foundation

Mary Inglesi

Noreen Inglesi

Law Offices of Michael T. Napolitano

Bill and Peg Paolino

Pools Plus Inc.

Rocky Hill Country Day School in Honor of Rudy Tanzi '76

Jennifer and Jonathan Scungio

Second Story Graphics

South County Sand and Gravel Co., Inc.

Dr. Rudy Tanzi

Peter White

www.notableworks.org